LOVE
COLORED
PENCILS

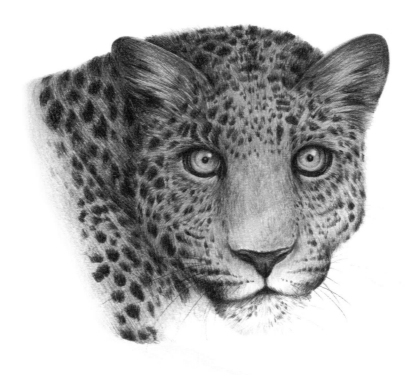

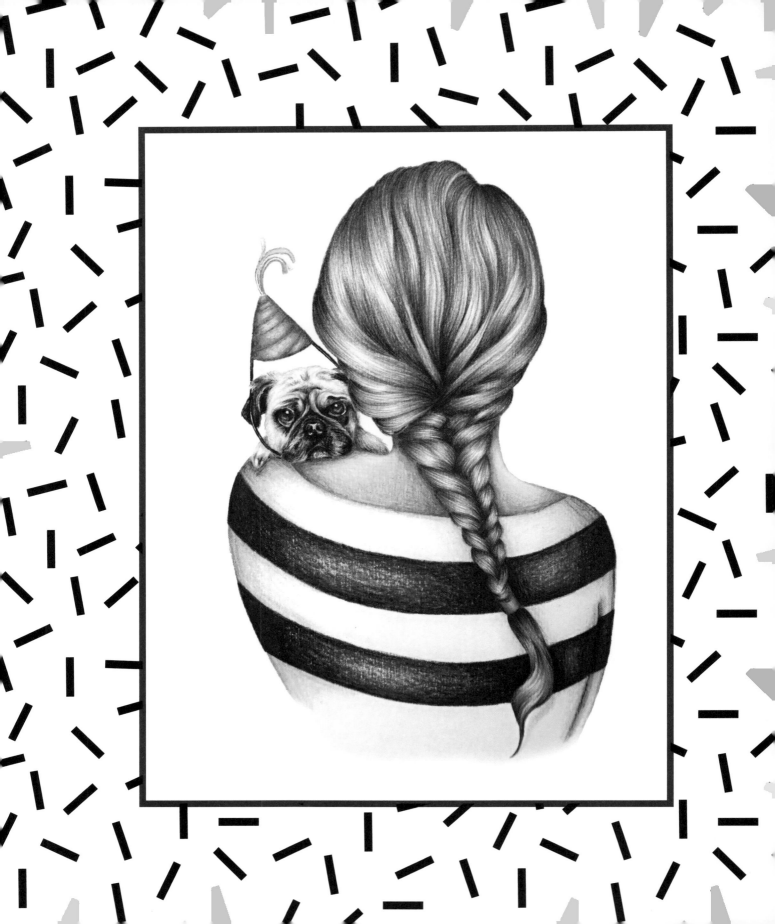

LOVE
COLORED
PENCILS

VIVIAN WONG

Inspiring | Educating | Creating | Entertaining

Brimming with creative inspiration, how-to projects, and useful information to enrich your everyday life, Quarto Knows is a favorite destination for those pursuing their interests and passions. Visit our site and dig deeper with our books into your area of interest: Quarto Creates, Quarto Cooks, Quarto Homes, Quarto Lives, Quarto Drives, Quarto Explores, Quarto Gifts, or Quarto Kids.

Conceived, designed, and produced by
Quarto Publishing plc, an imprint of The Quarto Group,
6 Blundell Street, London N7 9BH

Editor: Kate Burkett
Senior art editor: Emma Clayton
Designer: Joanna Bettles
Photographer: Phil Wilkins
Art director: Caroline Guest
Creative director: Moira Clinch
Publisher: Samantha Warrington

MIX
Paper from responsible sources
FSC® C104723

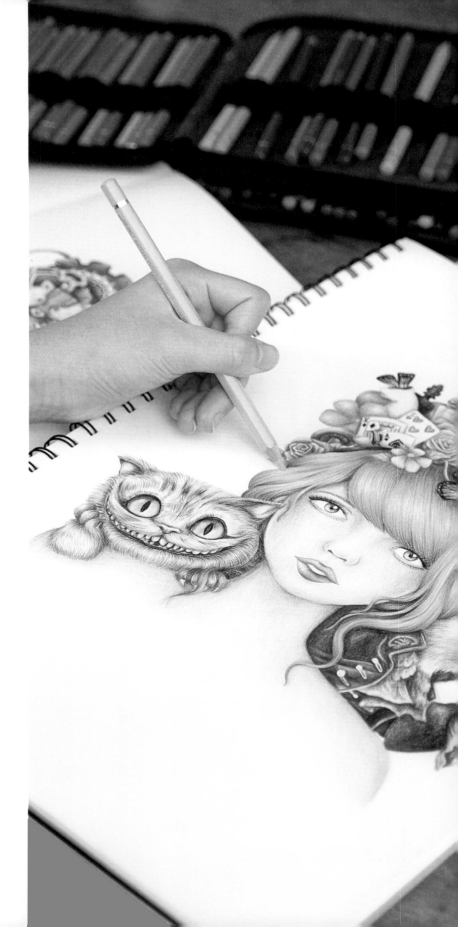

CONTENTS

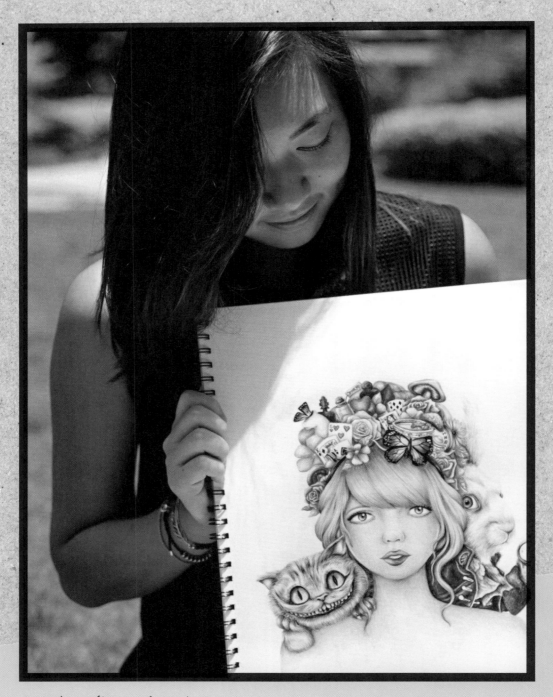

I think my Alice in Wonderland-
themed portrait will always remain
one of my favorite drawings. I love
the fantastical world inside the
story and how I managed to bring
that to life on paper.

MEET VIVIAN

Born and bred in Hong Kong, I began drawing at a very young age. I attended art lessons from the age of five—the only extracurricular classes I was willing to attend! It was in these classes that I learned how to use the tools of my trade—crayons, modeling clay, sketching pencils, watercolor paints, colored pencils, acrylic paint, and ink. Out of all the mediums that I encountered in my school years, colored pencils remained my favorite.

With colored pencils, you have full control. You are able to manipulate the lightness and darkness of colors quickly and easily. Colored pencils are also great for creating detailed drawings with a beautiful finish. And, of course, I love the feel of a traditional pencil in my hand while facing a blank canvas—being free to run the pencil across the page to create a wonderfully colorful drawing.

Animations and illustrations from pop culture have had a big influence on my artwork. Websites like Pinterest, Instagram, and Tumblr have been great sources of inspiration, and I use many reference images from these sites. I would describe my style as creative, colorful, and fantastical. I enjoy drawing thematic portraits, particularly because I love coloring hair and characters, and incorporating some kind of imaginative and evocative theme. I'm also a big fan of animation and graphic design, and doodling beautiful patterns.

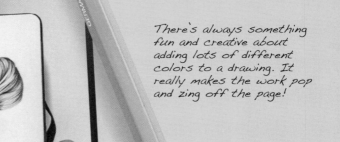

There's always something fun and creative about adding lots of different colors to a drawing. It really makes the work pop and zing off the page!

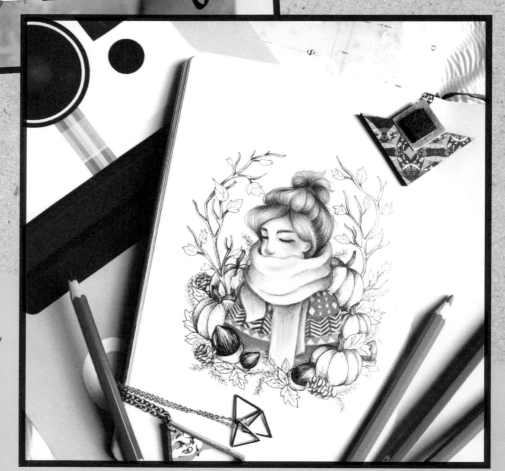

This is a sketch I made in collaboration with Etsy in which I mixed colored pencils with black pens. I think this creates such a wonderful contrast.

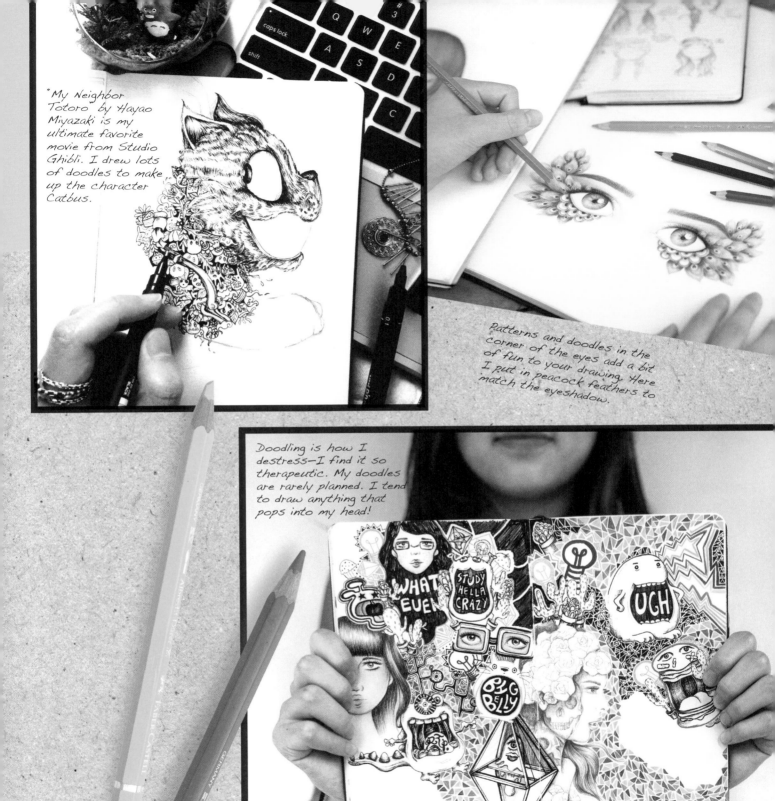

"My Neighbor Totoro" by Hayao Miyazaki is my ultimate favorite movie from Studio Ghibli. I drew lots of doodles to make up the character Catbus.

Patterns and doodles in the corner of the eyes add a bit of fun to your drawing. Here I put in peacock feathers to match the eyeshadow.

Doodling is how I destress—I find it so therapeutic. My doodles are rarely planned. I tend to draw anything that pops into my head!

I'm inspired alot by cartoons and animations. Pokemon was a big part of my childhood, so it's only natural it appears here!

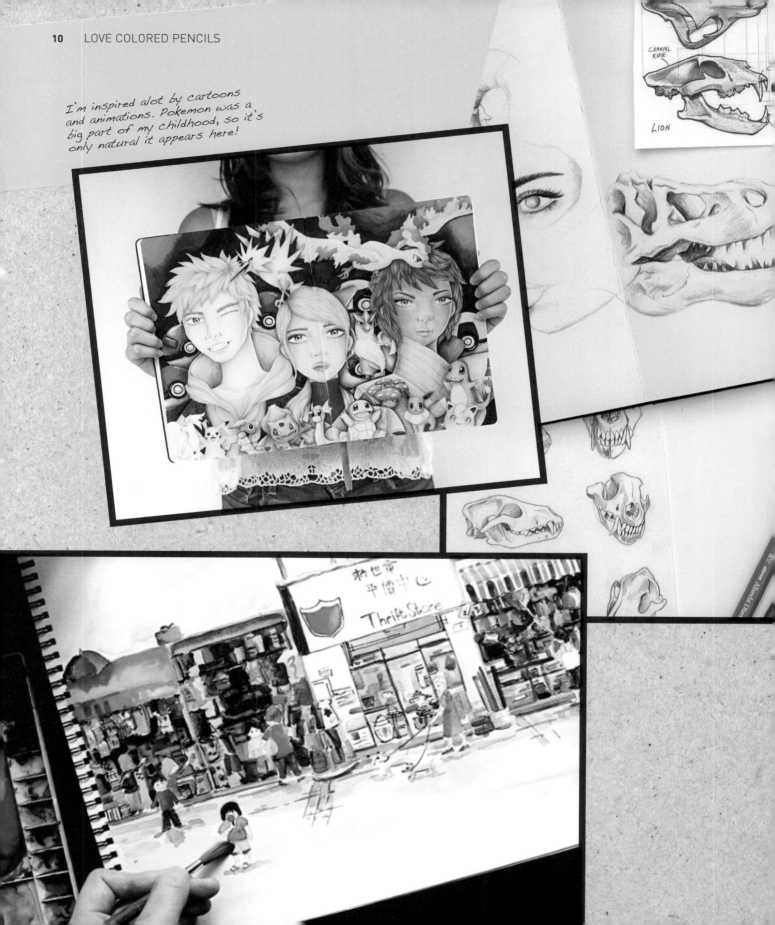

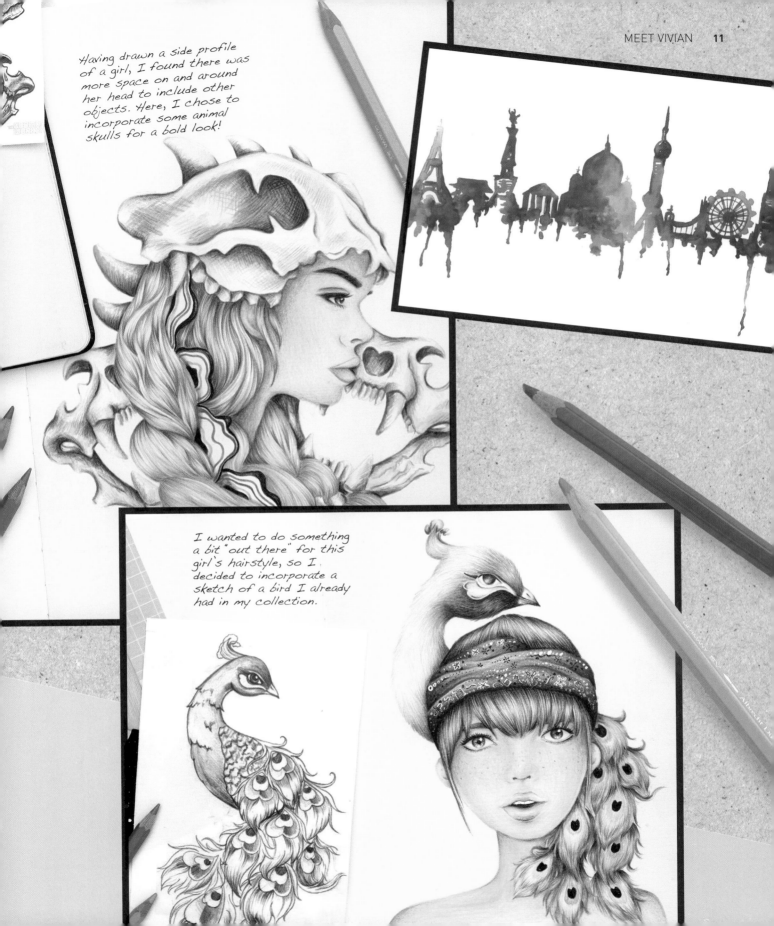

Having drawn a side profile of a girl, I found there was more space on and around her head to include other objects. Here, I chose to incorporate some animal skulls for a bold look!

I wanted to do something a bit "out there" for this girl's hairstyle, so I decided to incorporate a sketch of a bird I already had in my collection.

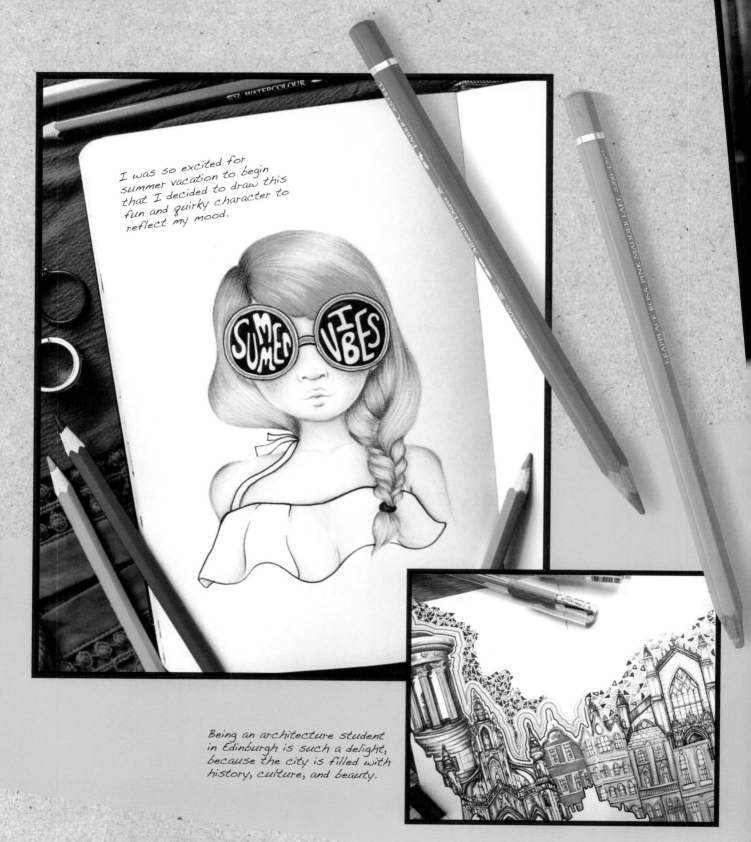

I was so excited for summer vacation to begin that I decided to draw this fun and quirky character to reflect my mood.

Being an architecture student in Edinburgh is such a delight, because the city is filled with history, culture, and beauty.

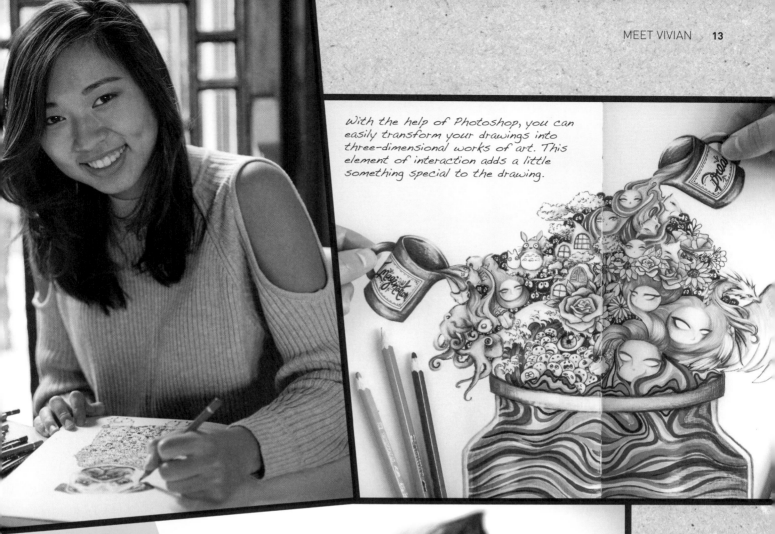

With the help of Photoshop, you can easily transform your drawings into three-dimensional works of art. This element of interaction adds a little something special to the drawing.

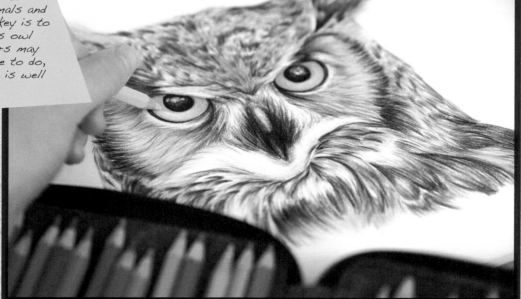

When it comes to coloring in animals and their fur, the key is to be patient. This owl and his feathers may take a long time to do, but the result is well worth it!

DEC

chapter

1

TOOLS AND TECHNIQUES

TOOLS AND MATERIALS

Choosing the correct tools and materials is extremely important as they will form the foundation of your drawings. It is also worth investing in high-quality equipment, which should last for a much longer time.

1 COLORED PENCILS

There are two main types of colored pencils: wax core and oil core. Wax core pencils are generally more popular and cheaper. The colors are softer and produce a slightly rougher texture. Oil core pencils have a harder core, which means they are less prone to breaking easily. They are slightly more expensive than wax core pencils and the final result is smoother and more pigmented.

I personally like to use Faber Castell's colored pencils as this has been the brand I've grown up using. They are very durable and the color always comes out beautifully on paper.

2 BLENDING STUMP

I like to use a blending stump when it comes to blending and softening colors. The paper fibers on the blending stump drag and mix the colors on the paper across and into the paper's surface to create a smooth and soft effect. A blending stump is made out of tightly compressed paper. Sandpaper is commonly used to clean and resharpen the blending stump.

3 SKETCHBOOKS/PAPER

My go-to sketchbooks are Moleskine. The paper is very smooth and holds the pigmentation of the colored pencils very well. The colors appear softer while still retaining their boldness and vibrancy.

Choosing the right paper is all about preference and experimentation. A general rule is to keep an eye out for the finish of the paper, the paper weight, and dimension. The finish of the paper refers to the texture. A cold press finish is the most common because it has a balance of texture and smoothness. Paper weight refers to the thickness of the sheet of paper. Generally, if you want to layer many colors, a heavy-weighted paper is more suitable. You can choose different-sized paper depending on what you are drawing. I use a half-letter sized sketchbooks for smaller works and letter size / tabloid sketchbooks for bigger ones.

4 SHARPENER

Sharpeners are a must! It is best to try and keep your pencils sharp in order to create accurate and detailed drawings. However, try not to sharpen the pencils too much as the lead is more prone to breaking.

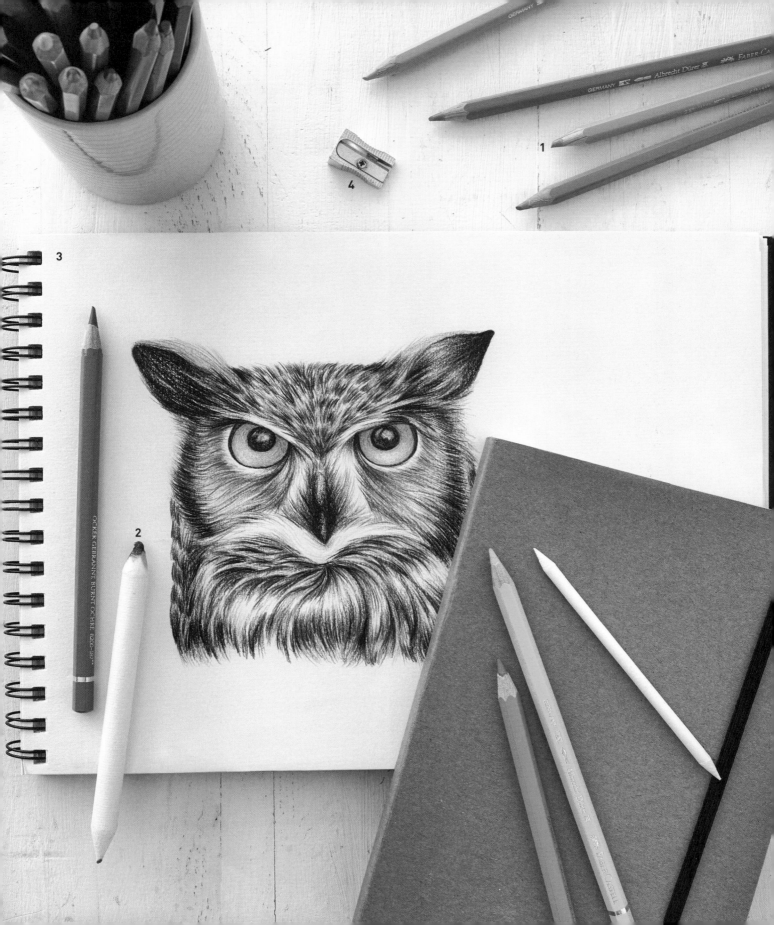

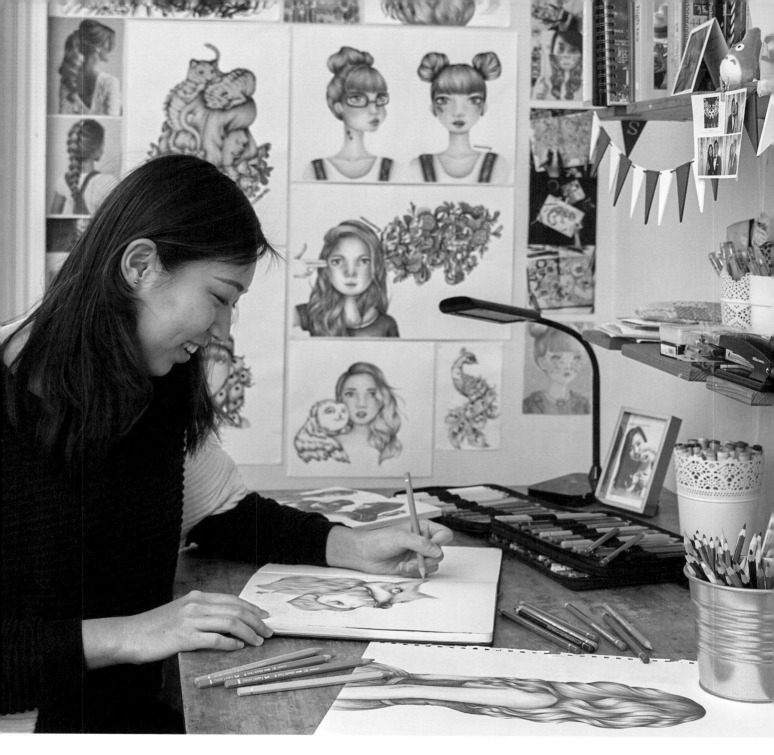

HOLDING YOUR PENCIL

There are several ways you can hold your pencil when it comes to coloring. These variations will achieve different textures on paper. Furthermore, changing the pressure on your pencil will also change the tone and texture.

1 NORMAL

Make sure to have the pencil resting comfortably on your middle finger and grip the pencil with your index finger and thumb. You don't need to grip too tightly. Your fingers should only be around ¾in. (2cm) away from the tip of the pencil. You can also rest your thumb on your index finger to create a stronger grip, which means you will have better control of the pencil.

2 PERPENDICULAR

Holding the pencil perpendicularly creates sharper pencil strokes. The position of your fingers will be the same as how you would normally hold a pencil, except this time, angle your pencil perpendicularly to the paper. The distance between your thumb and index finger will be closer, providing extra support for the pencil and your grip.

SIDEWAYS

Holding your pencil sideways is perfect for quickly filling in large areas with color.

3 Finger closer

By holding your pencil sideways and close to the tip, you can create darker strokes. Curl your middle finger, ring finger, and pinkie around the pencil. Grip onto the pencil with your thumb, it should be near your middle finger. Placing your index finger near the tip of the pencil (about ½in. / 1cm) will give you more control over the strokes you make.

4 Finger farther back

By holding your pencil sideways and farther away from the tip, you can create softer strokes. Hold the pencil in the same way as described in 3 above, except make sure that your fingers are farther away from the tip of the pencil (about 1¼–1½in. / 3–4cm).

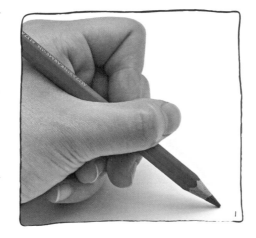

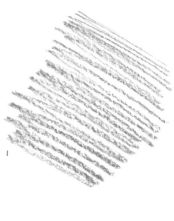

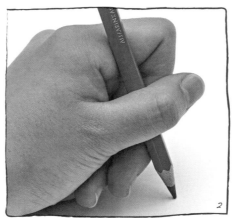

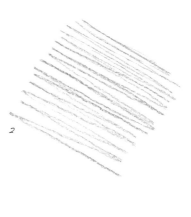

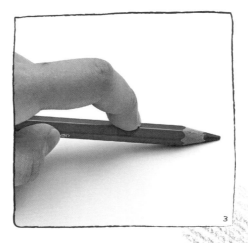

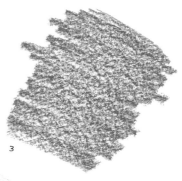

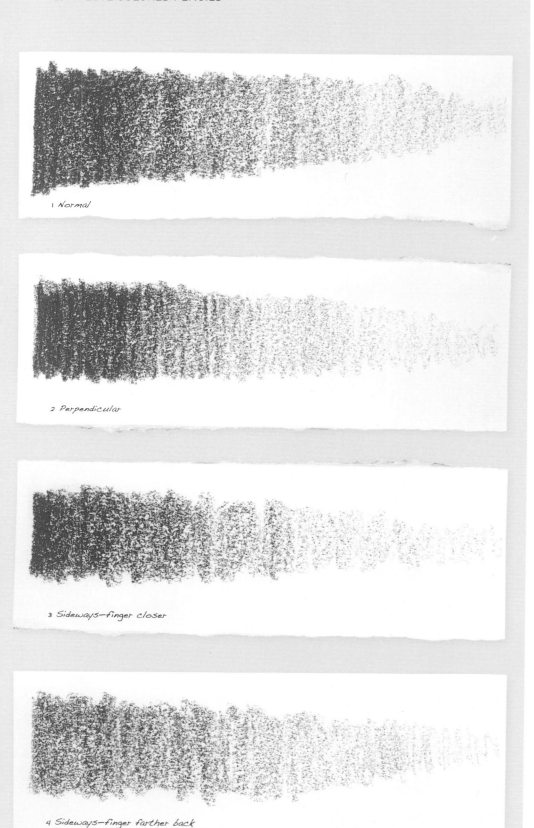

1 *Normal*

2 *Perpendicular*

3 *Sideways—finger closer*

4 *Sideways—finger farther back*

PRESSURE

By varying the amount of pressure you exert on the pencil, you can create dark and light tones, which will be extremely important when it comes to coloring in and making items look three dimensional.

You can create dark to light tones using the four different ways of holding your pencil on the previous page. The way you exert pressure onto the pencil is the same, regardless of which method you choose to use to hold your pencil.

To create darker tones, you must use more pressure. Make sure you grip and pinch the pencil very tightly between your index finger and thumb. You can also use your thumb to firmly press the pencil against your middle finger for support.

To create lighter tones, use less pressure. You can lighten your grip on the pencil between your index finger and thumb. The lighter your grip, the lighter the color will be.

However, as you can see in 4 on the left, the tone created by holding your pencil sideways and farther away from the tip is slightly lighter than the three other methods above it. As described on the previous page, this method of holding your pencil will create softer strokes, so the pressure you exert on the pencil using this method will inherently be lighter, and will create lighter tones.

TRY IT YOURSELF

Use this page to practice the blending techniques.

If you are afraid the color will come out too strong, remember you can always start off lightly and gradually build up tone and color.

1 Normal

2 Perpendicular

3 Sideways—finger closer

4 Sideways—finger farther back

HATCHING

Hatching is a mark-making technique that is used to create shade, tones, and textures through the use of close parallel lines. The distance between each line will determine how light or dark the area will be.

1 PARALLEL HATCHING

Lines are drawn vertically, parallel to each other. The closer the lines, the darker the area will appear.

2 MULTICOLORED PARALLEL HATCHING

Use different combinations or gradients of color.

3 MULTICOLORED SLANTED PARALLEL HATCHING

Essentially the same technique as normal parallel hatching, only the lines here are slanted at an angle and the colors are layered on top of each other.

4 CONTOUR HATCHING

When you want to create shadows on a curved object, create hatches that complement the curves of the object.

5 BASKET HATCHING

Short parallel hatches that are closely placed in groups next to each other at various angles.

6 MULTICOLORED BASKET HATCHING

A demonstration of basket hatching with different colors.

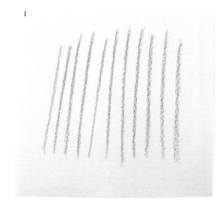

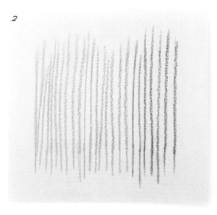

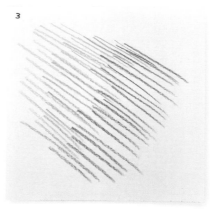

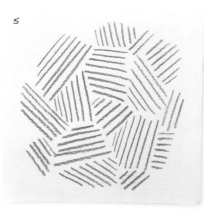

TRY IT YOURSELF

Use this page to practice the hatching techniques.

Remember it's perfectly fine if the lines are uneven or not completely straight. In fact, it will make them appear more natural.

CROSSHATCHING

Crosshatching is a blending technique, traditionally used to build up areas of tone in drawings using a linear medium. In colored-pencil work, these methods are an effective way to mix colors or to modify them.

1 BASIC CROSSHATCHING

Draw one layer of hatch marks, then another layer on top. Use to build layers and create dark areas.

2 FINE CROSSHATCHING

Vary the distance between each hatched line to create darker shades. The lines here are finer than those in basic crosshatching.

3 EXTREMELY FINE CROSSHATCHING

Creates intense, rich tones and gives the illusion of a darker shadow. The close marks appear to blend together when viewed from afar.

4 PERPENDICULAR CROSSHATCHING

Although the crosshatchings demonstrated so far have been oriented in a slanted fashion, there is no rule on the angle of the lines. Here is an example of crosshatching at perpendicular angles.

5 CONTOUR HATCHING

The contour hatch is layered on top in a perpendicular direction and helps enhance the depth of the shadow.

6 MULTICOLORED CROSSHATCHING

Play around by layering different colors on top of each other.

1

2

3

4

5

6

TRY IT YOURSELF

Use this page to practice the crosshatching techniques.

STIPPLING

Stippling is a type of mark-making that involves creating small dots that can be arranged close together or farther apart to generate various shades. The denser the dots are, the darker the shade.

1 SPACING OF DOTS: FAR APART

With a sharp pencil, use small, quick wrist-flicking motions to create small dots over your paper. The farther apart the dots are, the lighter the shade will be when it comes to completing a drawing by stippling. Decrease the density of the dots by applying less pressure on your pencil.

2 SPACING OF DOTS: MEDIUM

By stippling the dots closer to each other, you can create a darker shade.

3 SPACING OF DOTS: TIGHT

You can create dark tones by ensuring the dots are very closely knitted, with less space in between. You can also increase the density of the dots by applying more pressure on your pencil.

4 DARK TO LIGHT: ONE COLOR

This is an example of creating a gradual tone change from dark to light, using one color. The closer you stipple the dots to each other, the darker the shade will be.

5 DARK TO LIGHT: THREE COLORS, EVEN SPACING

You can also create a gradual tone change by using three or more colors. This is like pointillism. The spaces between the dots are even throughout because the colors highlight the tone change, unlike swatch 4 (one color: dark to light tone). Here I used red, orange, and yellow.

6 DARK TO LIGHT: THREE COLORS, TIGHT SPACING

This is another example of tonal change using three colors, but this time the dots are stippled together much more tightly. Here I used purple, dark blue, and light blue.

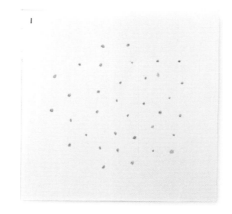

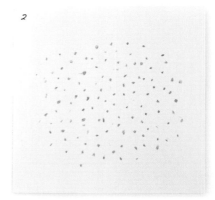

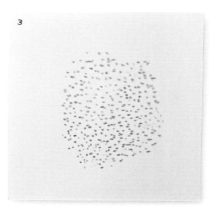

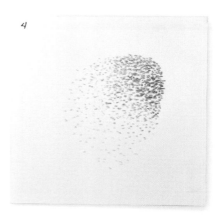

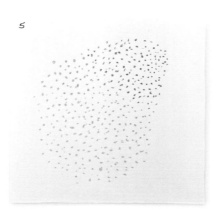

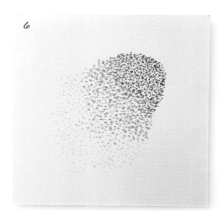

TRY IT YOURSELF

Use this page to practice the stippling techniques.

Because of the sheer amount of close-knit dots you will be creating, each dot does not have to be perfectly round.

SCRIBBLING

Scribbling is another technique used to create dark and light shades when coloring in. It is made up of random lines that can be circular and angular in different directions. There are no rules for scribbling—be as free and playful as you want!

1 CIRCULAR SCRIBBLES

By using a circular motion with your pencil, you can create round and curvy scribbles. The closer the lines are to each other, the darker the shade.

2 ANGULAR SCRIBBLES

You can also create scribbles with straight lines. Be playful and let the lines run in different directions.

3 BLENDING COLORS: ANGULAR SCRIBBLES

This is an example of blending three different colors using the angular scribbling method. Keep the colors close together and layer them on top of each other so that the effect looks more natural.

4 BLENDING COLORS: CIRCULAR SCRIBBLES

This example shows three different colors that have been blended using the circular scribbling method.

TRY IT YOURSELF

Use this page to practice the scribbling techniques.

BLENDING

Blending is an essential technique in colored pencil work. You are basically creating a smooth and gradual transition from one color to another. This can drastically improve the quality of your work and the overall smoothness of colors.

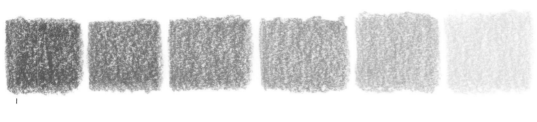

1 LAYOUT

First, lay out the colors you want to blend in a line next to each other. Leave a small gap between each color.

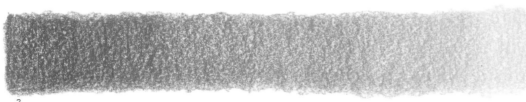

2 OVERLAP COLORS

Use each color to go over the gaps, overlapping each color closely to the next. This will ensure that you don't leave a harsh line between each color, which will look unnatural.

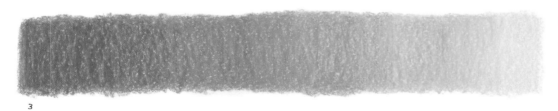

3 BLEND WITH WHITE PENCIL

You can blend all the colors together by using a white coloring pencil. Color generously to create a smooth effect.

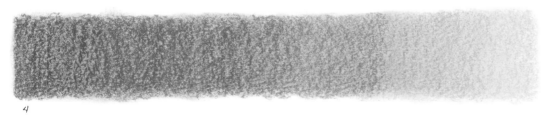

4 BLENDING STUMP

You can also use a blending stump to blend all the colors together. Once again, color generously for a smooth effect.

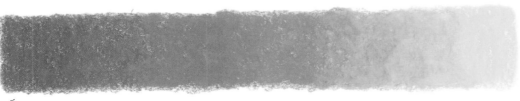

5 DAMP COTTON SWAB

Dampen a cotton swab with water and gently go over the colors using a circular motion.

TRY IT YOURSELF

Use this page to practice the blending techniques.

Remember to overlap each color or shade with the one next to it to avoid any awkward gaps or harsh lines.

VIVIAN'S "GO-TO" COLORS

The 12 colors featured here are my touchstones when it comes to drawing. These two pages illustrate some possible combinations of the colors. There is a range of warm colors, which include hues of red and yellow, and cool colors, which include hues of blue, blue-green, and blue-violet. Red and blue are my ultimate favorites, so I have included a few different shades. I definitely have a preference for bold and pigmented colors.

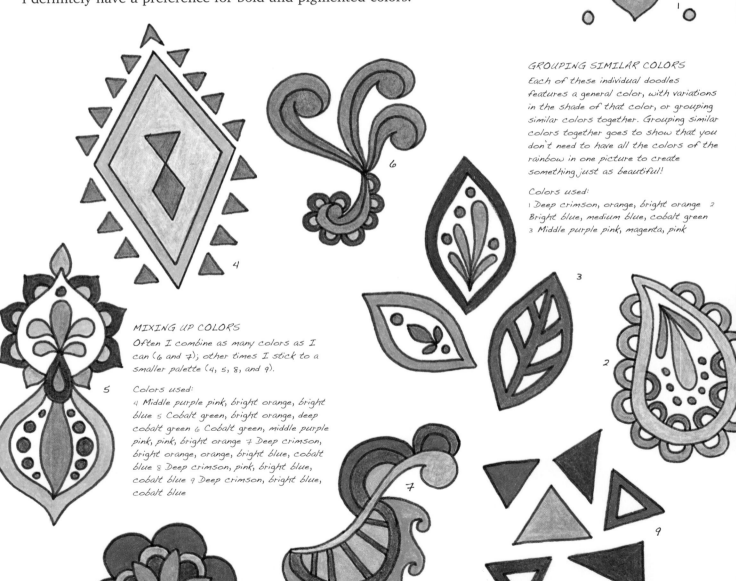

GROUPING SIMILAR COLORS
Each of these individual doodles features a general color, with variations in the shade of that color, or grouping similar colors together. Grouping similar colors together goes to show that you don't need to have all the colors of the rainbow in one picture to create something just as beautiful!

Colors used:
1 Deep crimson, orange, bright orange 2 Bright blue, medium blue, cobalt green 3 Middle purple pink, magenta, pink

MIXING UP COLORS
Often I combine as many colors as I can (6 and 7); other times I stick to a smaller palette (4, 5, 8, and 9).

Colors used:
4 Middle purple pink, bright orange, bright blue 5 Cobalt green, bright orange, deep cobalt green 6 Cobalt green, middle purple pink, pink, bright orange 7 Deep crimson, bright orange, orange, bright blue, cobalt blue 8 Deep crimson, pink, bright blue, cobalt blue 9 Deep crimson, bright blue, cobalt blue

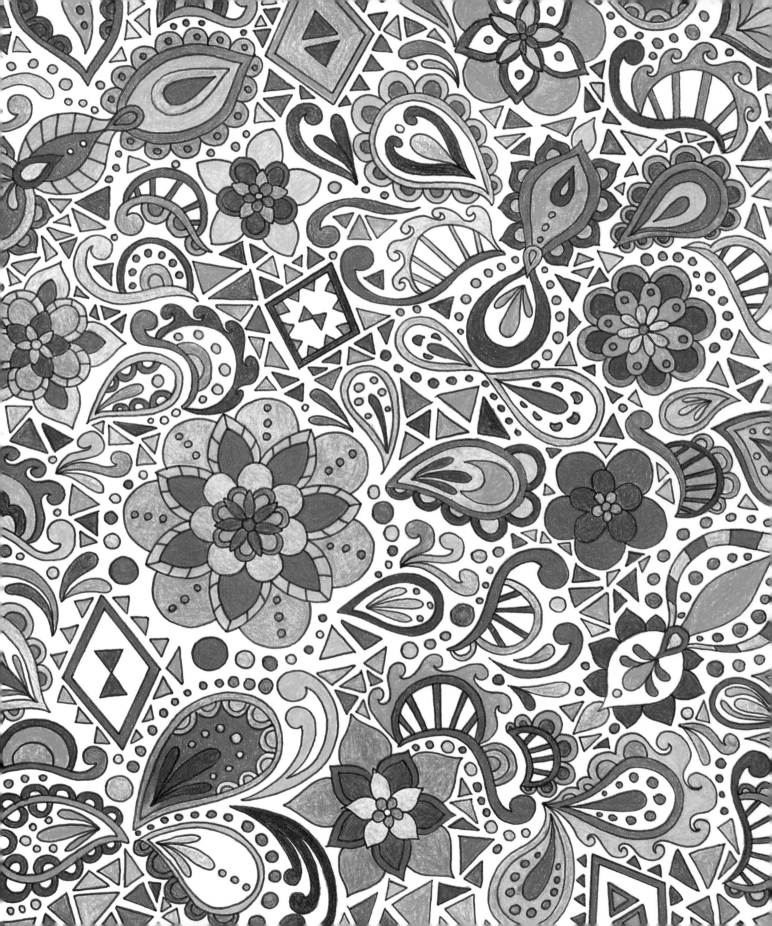

TRY IT YOURSELF

Use this page to create your own color combinations.

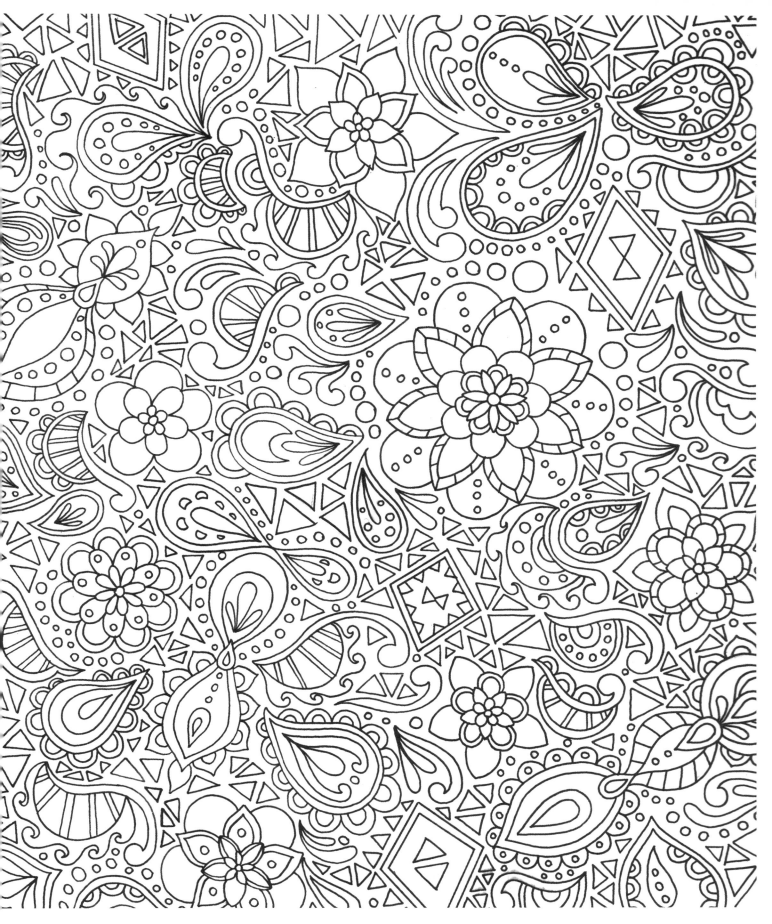

COLOR MIXES

Haven't got the exact color you were looking for in your pile of colored pencils? I've got the perfect trick for you guys. You can mix different colors together to create completely new ones. It's also a great way to create darker shades or warmer and cooler tones.

CREATING NEW COLORS FROM PRIMARY COLORS

Here you see three primary colors—red, blue, and yellow—as the starter swatch to each band. Along the top are 10 other colors shown hatched to a fairly dense tone; the row beneath shows the same color with the main primary color hatched over the top. On all of the mixed swatches I put the primary color down first with even-tone hatched strokes, and then put the original color over the top.

I used deep scarlet red as my favorite bright red primary. See in the lower strip of mixed swatches the incredible range of colors possible, from the pretty coral pink with light flesh to the rich chestnut with earth brown. Also note how the blues and greens along the top mix to make lovely neutral browns.

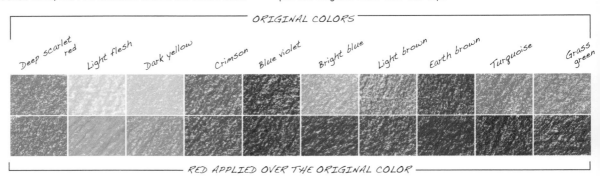

Here I use electric blue as my primary color. The blue has a subtle effect on the cool greens and violets, the reds can be modified to make rich browns, and any yellow will become a different hue of green.

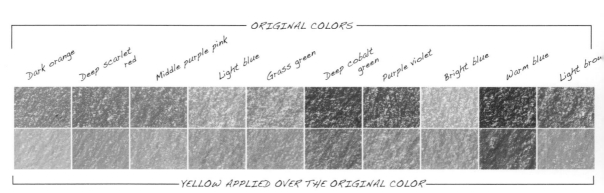

Dark yellow is my primary color here. All the original colors change quite dramatically from warm oranges to mossy or bright greens and lovely earthy tones when the yellow is hatched over the violet.

CREATING EVEN MORE NEW COLORS

Many more colors are possible by mixing—here nine different colors along the top row are mixed with the seven colors shown in the vertical strip on the left; some of these are primaries, others secondaries. Colors can be made darker, muted, or pastel. It can be a lovely effect when you see both colors as a veil of color, as in the outlined squares 1 and 2. Squares 3 and 4 are the mixes used in the "mix your own" section on the next spread.

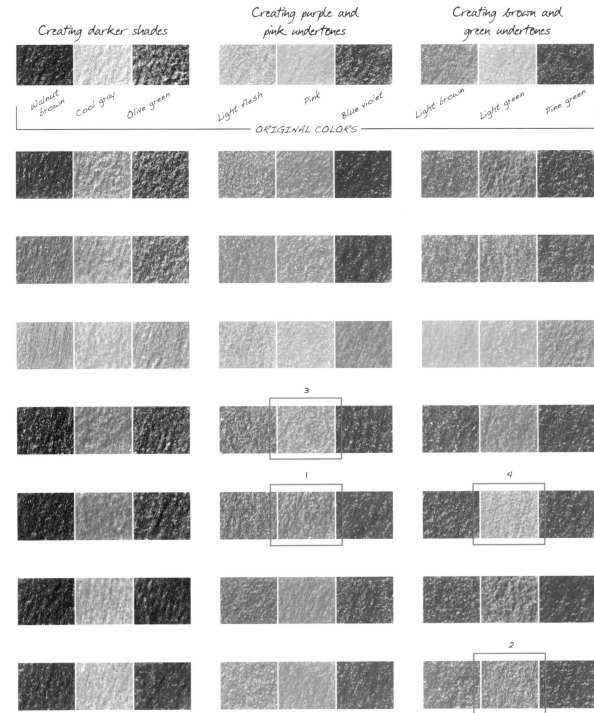

Creating darker shades

Creating purple and pink undertones

Creating brown and green undertones

Walnut brown *Cool gray* *Olive green* *Light flesh* *Pink* *Blue violet* *Light brown* *Light green* *Pine green*

— ORIGINAL COLORS —

COLOR APPLIED OVER THE TOP

Deep scarlet red

Orange

Dark yellow

Electric blue

Electric green

Purple violet

Fuschia

TRY IT YOURSELF

Work in layers to create different tonal values. Build up the tones by adding one, then two, then three layers to the different sides of the pencil. Write the color name (or number) underneath each filled-in pencil.

Mix of violet and blue for shading *Mix of greens and yellows*

KNOWING THE COLOR SPECTRUM

A color wheel is the best and most straightforward diagrammatic way to illustrate basic color theories. You will be able to learn the concept of primary, secondary, and tertiary colors, as well as complementary colors.

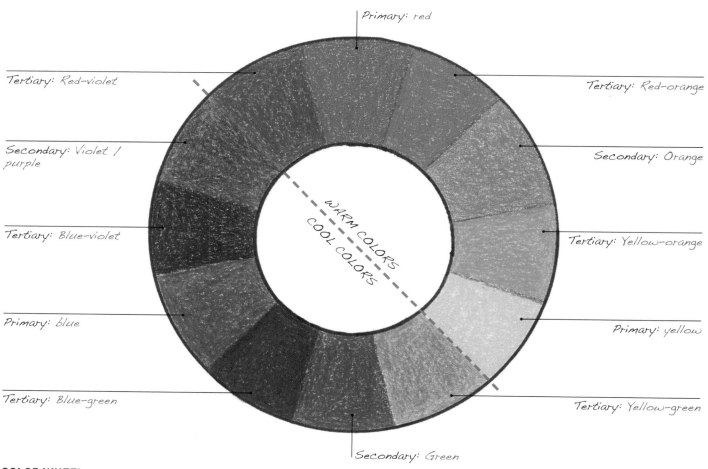

Primary: red

Tertiary: Red-violet

Tertiary: Red-orange

Secondary: Violet / purple

Secondary: Orange

WARM COLORS
COOL COLORS

Tertiary: Blue-violet

Tertiary: Yellow-orange

Primary: blue

Primary: yellow

Tertiary: Blue-green

Tertiary: Yellow-green

Secondary: Green

COLOR WHEEL

Primary, secondary, and tertiary colors
There are three primary colors, or hues: red, blue, and yellow. These are raw colors that cannot be made by mixing different colors together. Primary colors can be mixed with each other to create secondary colors: orange, green, and violet / purple. Red mixes with yellow to create orange; yellow mixes with blue to create green; blue mixes with red to create violet / purple. A tertiary color is made when you mix a primary color with the secondary color next to it on the color wheel. In this way, you can start to make the colors red–orange, yellow–orange, yellow–green, blue–green, blue–violet, and red–violet.

Warm and cool colors
Colors can also be sorted into two categories: warm and cool. If we split the color wheel in half down the middle, we learn that warm colors consist of reds, oranges, and yellows, extending to browns and tans. Cool colors consist of blues, greens, and purples, extending to some grays. Warm colors tend to come forward from the page and cool colors tend to recede. Understanding this can help you when choosing your colors.

Complementary colors
Those that are directly opposite one another on the color wheel are complementary colors. When placed together, the complementary colors make one another more bold and intense. Orange pairs with blue; red pairs with green; yellow pairs with purple.

EXTENDING PRIMARY HUES

The range of colors you can create using primary plus some secondary colors is endless. Here are some examples of how you can achieve new colors by gradually adding more primary and secondary colors on top of each other.

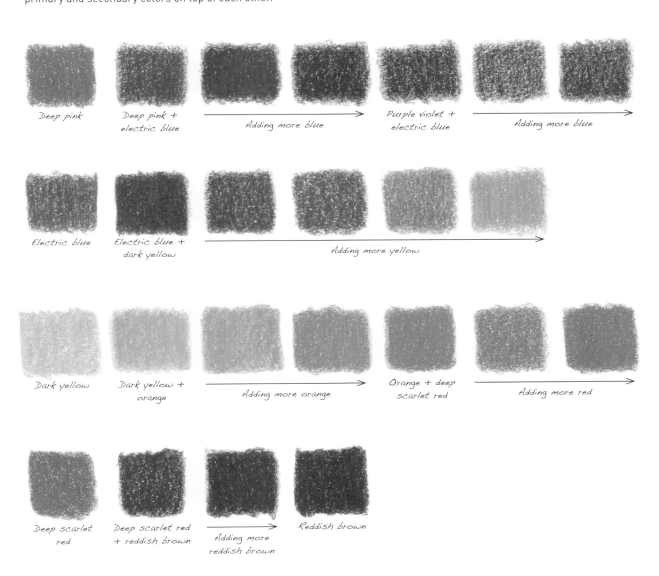

Deep pink

Deep pink + electric blue

Adding more blue →

Purple violet + electric blue

Adding more blue →

Electric blue

Electric blue + dark yellow

Adding more yellow →

Dark yellow

Dark yellow + orange

Adding more orange →

Orange + deep scarlet red

Adding more red →

Deep scarlet red

Deep scarlet red + reddish brown

Adding more reddish brown →

Reddish brown

WHAT IS TONE?

Tone is the relative darkness and lightness of colors. Some colors are naturally lighter in tone than others. For example, yellow is light in tone, but indigo is dark. Of course, you can darken the tone of the yellow by adding dark shades such as gray or brown.

CREATING TONES WITH COLOR

This grid illustrates how you can darken and lighten the tone of different colors by mixing with a dark gray. The grid also illustrates the different changes in pressure you exert on your pencil when you transition from a dark tone to a light tone.

COLORS AND THEIR NATURAL TONE

Some colors and their pigmentations are naturally lighter in tone compared to other colors. For example, a yellow is lighter in tone than a dark blue. Therefore, in order to darken the tone of the yellow, you can mix it with other colors such as dark gray.

LIGHT YELLOW:
Naturally light
in tone

DARK BLUE:
Naturally
dark in tone

But you can mix colors to create darker tones:

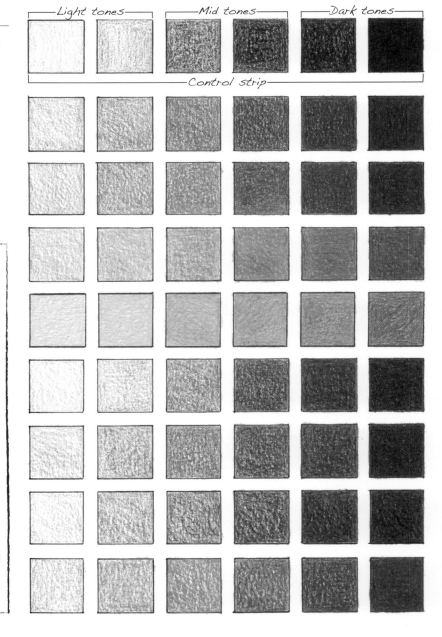

TRY IT YOURSELF

Use this page to practice creating different tones.

Start off with a light pressure on your pencil when creating the color mixes so that you can build the tone and darkness in layers.

BRINGING IT ALL TOGETHER

Here, I demonstrate three different ways to color in a sphere and make it look three dimensional by adding shading. By using and combining some of the techniques you have learned previously, you can create similar effects.

CREATING LIGHT AND SHADE WITH CROSSHATCHING

Learn how to color in a sphere using the crosshatching method. You can create shade, light, and a three-dimensional effect by using only one color.

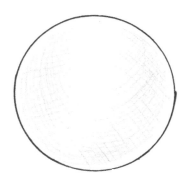 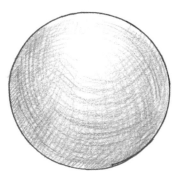 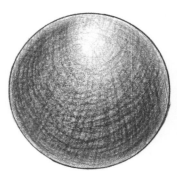

1 Begin by creating faint contour crosshatching lines around the left and right of the sphere. Keep a light pressure on your pencil.

2 Increase the pressure on your pencil to create darker contour crosshatching lines around the edges. Make the crosshatching finer to create darker shadows. Concentrate most of the crosshatching near the bottom of the sphere.

3 Keeping strong pressure on your pencil, create much darker and finer crosshatching. This will intensify the shadows created. Make sure to keep the lines very close to each other to ensure that the sphere looks more three dimensional.

COMBINING SCRIBBLING AND STIPPLING

This is another way to color in a sphere, using the stippling and scribbling methods combined. Use a blending stump to blend the three chosen colors together smoothly. (These colors are also featured as my go-to colors on pages 32–35.)

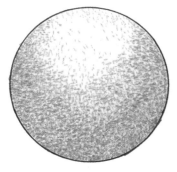 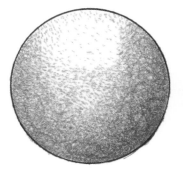

1 Use orange to stipple all over the left, right, and bottom areas of the sphere. Then, use red to create another layer of stippling, only this time near the bottom and outer edges.

2 Use magenta to create circular scribbles around the bottom edges of the sphere. This will help cover some of the harsh stipple marks while creating intense shading.

3 With circular motions, take a blending stump and go over the sphere to blend the colors together smoothly.

> Why not try these techniques with different colors? Have fun experimenting with a combination of your favorite colors!

TRY IT YOURSELF

Use this page to practice the three light and shade methods.

CREATING LIGHT AND SHADE WITH SCRIBBLING

Use five different colors to build shade and dimension, and a white pencil to blend all the colors together.

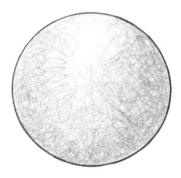

1 Use light electric green and cobalt green to faintly create a mix of circular and angular scribbles around the edges of the sphere. Concentrate the scribbles near the left, right, and bottom. Remember to keep the top-center area white, as this is where the light shines.

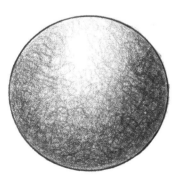

2 Use olive green and warm blue to create more circular and angular scribbles around the edges. Increase the pressure of your pencil to create darker shades.

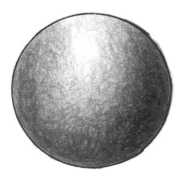

3 Use reddish brown to create a darker shade around the bottom edges. Exert strong pressure on your pencil. Go over the sphere with a white pencil to blend the colors together smoothly.

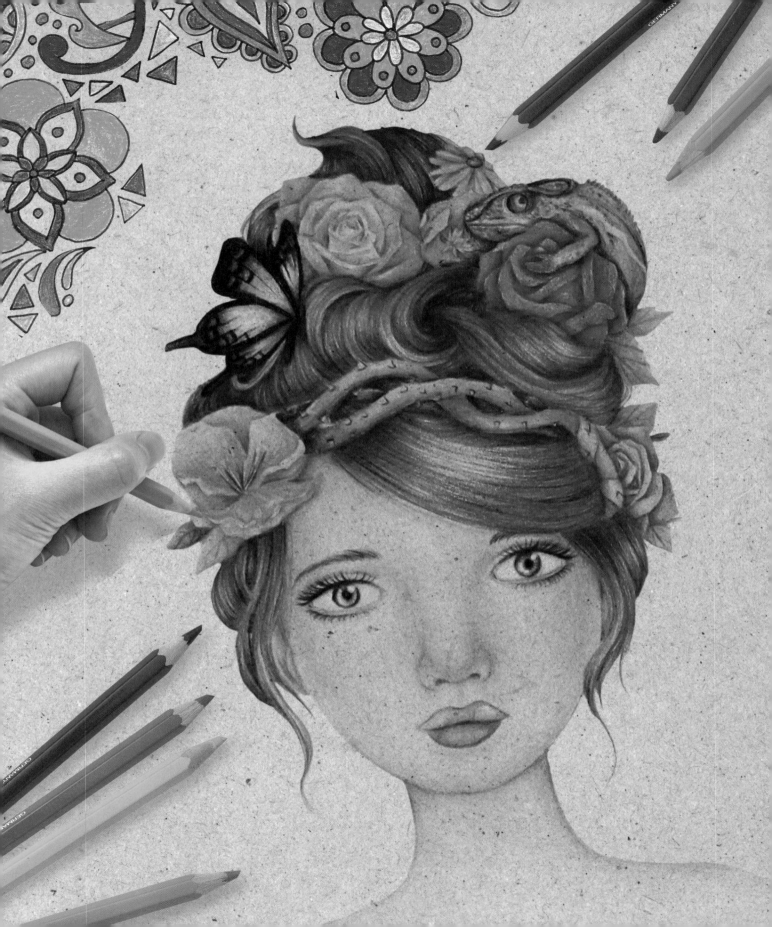

chapter

2

HOW TO COLOUR

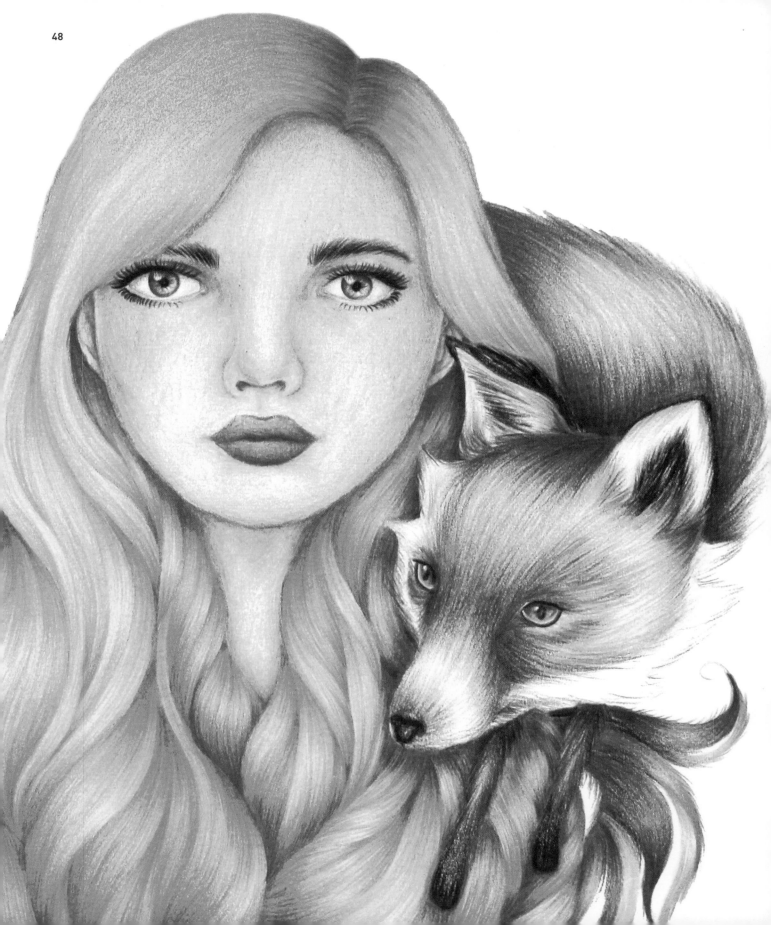

EYES

When it comes to coloring eyes, it is all about the details, and layering in order to build depth. Using a range of colors and tones will help create a realistic-looking eye and bring it to life.

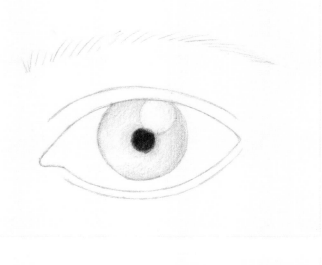

Turquoise

1 Create a base color by lightly coloring in the iris—here I used turquoise. Focus more of the color around the edges of the iris and pupil. Fill in the pupil with black. Leave a white spot uncolored to act as the reflection and light spot of the eye.

Electric blue

Navy

2 Find a darker shade of your chosen base color—I used electric blue. Color over the same areas as you did previously. Apply more pressure to your pencil so that the color comes out darker. Another key step is to create thin lines starting from the edge of the iris. Flick your strokes toward the middle of the iris, and repeat the same process from the edge of the pupil. This imitates the structure of the iris.

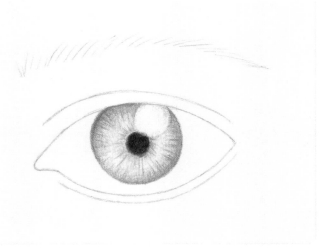

Walnut brown

Black

3 Use an even darker shade of the color you chose to create more depth and define the structure of the iris—I used navy. Apply more pressure to your pencil and go over the same areas mentioned in the previous step. Darken a few of the lines in the iris.

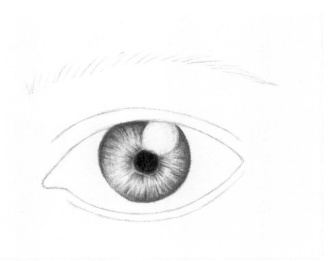

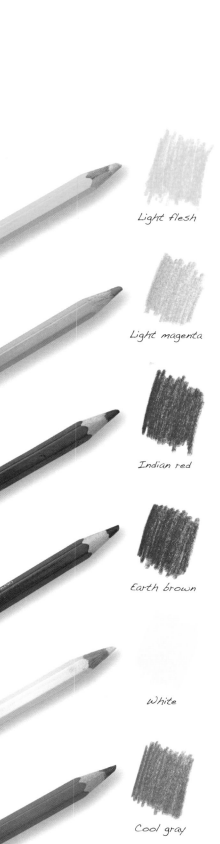

Light flesh

Light magenta

Indian red

Earth brown

White

Cool gray

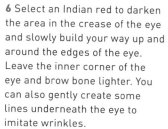

4 Using a walnut brown and black, emphasize and define the shape of the iris by coloring around the edges, especially near the upper waterline of the eye. Further darken some lines within the iris to add variety and depth. Then use black to lightly create thin curved strokes in the white circle to imitate the reflection of the eyelashes.

5 After completing the iris, move on to the skin around the eye. Here, I used a light flesh color to lightly color around the edges of the eye up to the eyebrow. Darken the areas in the crease of the eye and under the bottom edge of the eye.

6 Select an Indian red to darken the area in the crease of the eye and slowly build your way up and around the edges of the eye. Leave the inner corner of the eye and brow bone lighter. You can also gently create some lines underneath the eye to imitate wrinkles.

Pick a light magenta to color in the caruncle of the eye.

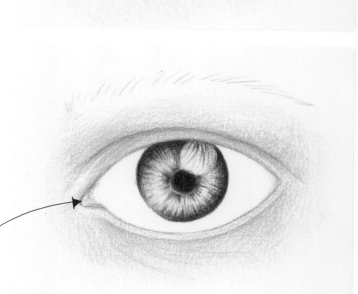

7 Use an earth brown over the same areas as before, focusing mainly on the crease of the eye. Then use a walnut brown to layer over the top. This is the darkest area of the skin, so we need to emphasize it clearly. Use the walnut brown to lightly outline the shape of the eye.

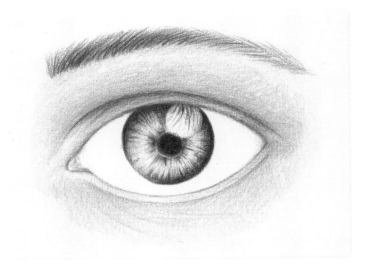

8 Use black to add in the eyelashes. Start from the waterlines of the eye and use a quick wrist-flicking motion to create thin curved lines going upward. Start with long strokes on the outer corner of the eye, gradually decreasing the length as you reach the inner corner. The bottom eyelashes should be relatively shorter.

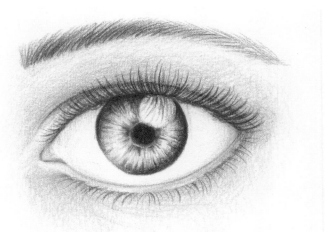

9. Use a white to color over the skin, blending the colors together smoothly.

Use a cool gray to lightly shade the top and bottom half of the sclera, offsetting the white, and add some shadow.

SHAPE AND COLOR

The shape and color of an eye can be changed to create different expressions and looks. You can be creative and add colorful eyeshadow, patterns, and doodles, and even change the iris into a rainbow of colors. Be playful and experiment—there is no right or wrong. The technique for coloring in the eye and skin around it is essentially the same as previously shown.

BROWN EYE + THICK EYELASHES

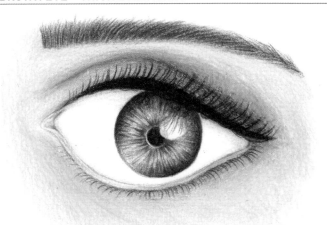

A key tip to creating realistic eyelashes is to sharpen your pencils!

RAINBOW-COLORED EYE

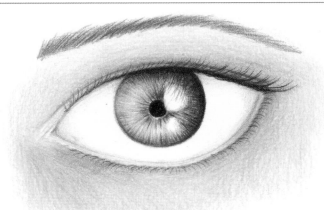

Change the color of the iris into something more colorful, like a rainbow.

GREEN-COLORED EYE

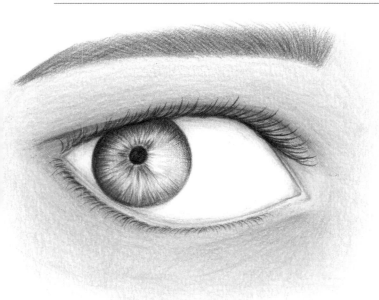

Having a contrast between the light and dark areas of this iris makes it look more realistic.

ORANGE/BROWN EYESHADOW

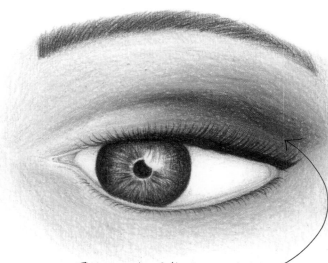

This example of blending eyeshadow colors into the skin color is all about slowly layering colors on top of each other. Use a blending stump or white pencil to blend the colors together smoothly.

SAD EXPRESSION

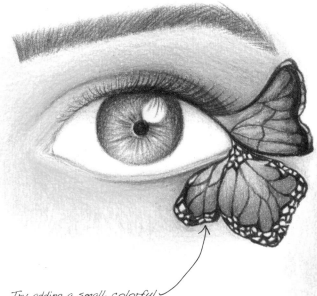

Conveying the expression of a face highly depends on the eyes. By simply changing the arch of the eyebrow and the shape of the eye, and adding a few lines in the skin, you can drastically change the expression. Here is an example of a sad or worried expression.

FIERCE EXPRESSION

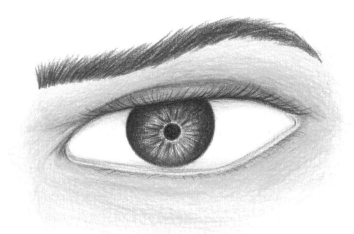

Here is another example of changing the expression on the face by altering the shape of the eye, eyebrows, and even the color of the iris.

Try adding a small, colorful doodle that extends from the lid of the eye to the outer corner.

EXTREME EYESHADOW

Now it is time to be creative. Try adding patterns and doodles on the corner of the eye, like face paint. This example of butterfly wings matches the iris and eyeshadow color.

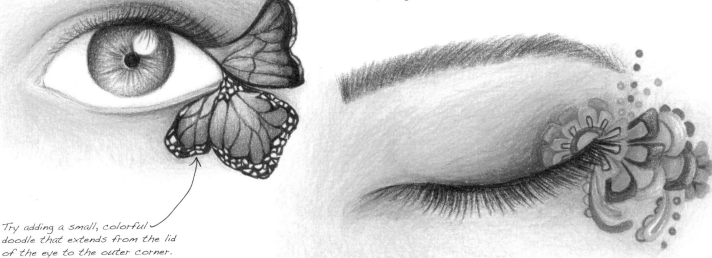

TRY IT YOURSELF

Colors used

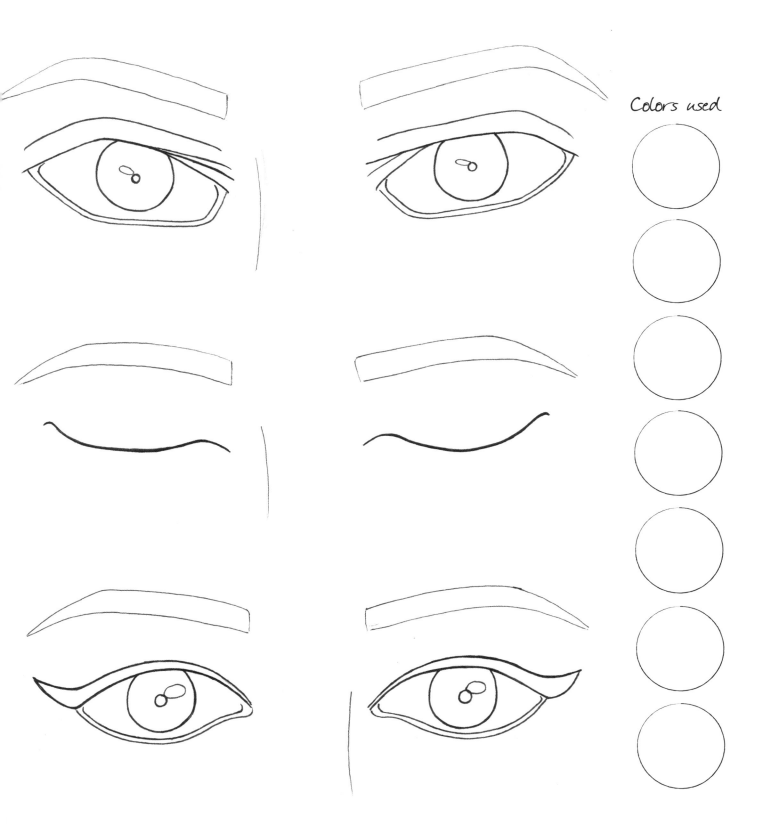

Colors used

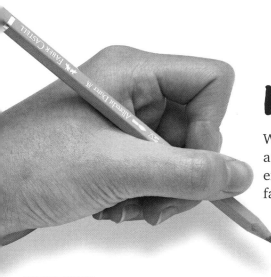

NOSES

When it comes to coloring the nose, there are quite a few specific lines and contours that are necessary to define the form and shape. For example, shadowing is important to make the nose stand out from the face, while contouring the bridge of the nose further defines the form.

FRONT VIEW

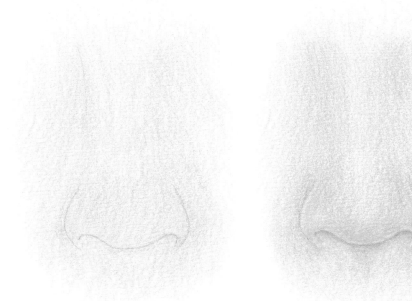

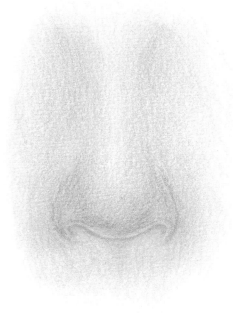

1 Begin by using a light flesh to lightly color in the nose. Don't worry about creating any shadows just yet—this is just the base color.

2 Use the same flesh color you used in the first step to define the structure of the nose. Apply a bit more pressure to your pencil to create darker colors in the nostrils, the edges of the nose, the edges of the bridge, and the bottom of the nose. Leave the bridge lighter than other areas.

3 Select a cinnamon color and go over the structure of the nose to emphasize the shape even more. Build up the colors slowly, without applying too much pressure to your pencil, as the colors may turn out to be too harsh.

Light flesh *Cinnamon*

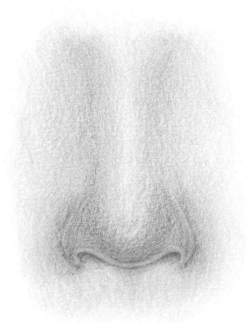

4 Use an Indian red to further darken the nostrils, and the edges, bottom, and around the tip of the nose to highlight the features. Lightly build up shadows around the bridge.

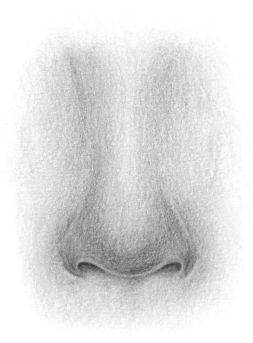

5 Take a walnut brown to define the features one last time, especially the nostrils and the edge and bottom of the nose.

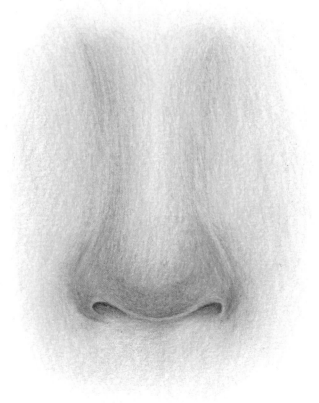

6 Lastly, use a white pencil to color over the whole nose, blending the colors together smoothly.

Indian red

Walnut brown

White

SIDE VIEW

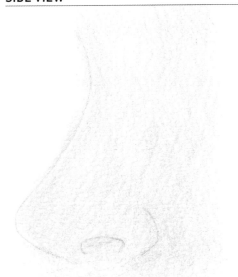

1 First, use a light flesh color to lightly color the entire nose. This will be your base color.

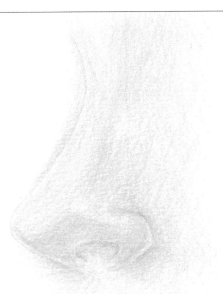

2 Second, using the same flesh color, start to define the structure of the nose. Increase the pressure on your pencil ever so slightly to darken areas around the edges of the nose, the nostril, and the edge of the nose bridge. Leave the nose bridge lighter than other areas.

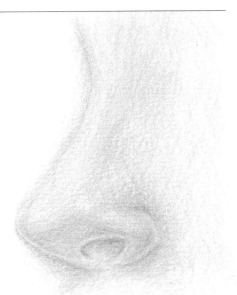

3 Then take a cinnamon color to further define the structure of the nose. Color over the same areas as in Step 2.

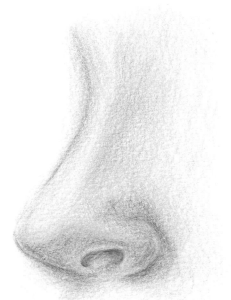

4 Next, take an Indian red to create shadows. Keep a light pressure on your pencil and build up shade around the edges of the nose. Use this color to also emphasize the bridge by creating a darker shade on the side.

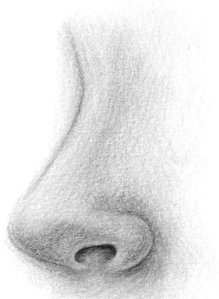

5 Then select a walnut brown. Use this to color in the nostrils, the edge of the nose, and near the tip of the nose.

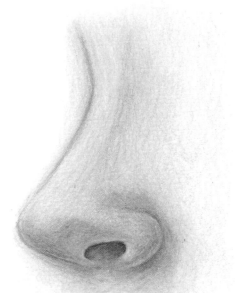

6 Lastly, use a white pencil to color over the whole nose to make the colors appear smoother.

TRY IT YOURSELF

Colors used

Colors used

LiPS

When we color in lips, we must remember we are filling in a round and curvy object. Make the center the lightest area and build shadows around the edges. This will help ensure the lips pop.

Do you ever notice the fine lines you have on your lips? To imitate the texture these lines create, make thin strokes with your colored pencils.

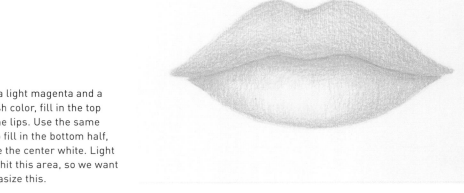

Light magenta

1 Using a light magenta and a light flesh color, fill in the top half of the lips. Use the same colors to fill in the bottom half, but leave the center white. Light tends to hit this area, so we want to emphasize this.

Light flesh

Dark flesh

2 Take a dark flesh to color over the same areas as in Step 1. This time, instead of using back and forth strokes, make the strokes curve in one direction, following the shape of the lips. This is to imitate the lines and texture that occur on lips. Darken the area right between the top and bottom halves of the lips.

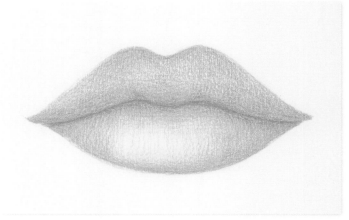

Bright red

3 Use a bright red to darken further, and shade in the edges of the lips and between the upper and lower lips. Use the red to emphasize some of the lines on the lips, highlighting the natural texture. You can also start coloring in the skin around the lips. Use a light flesh color to do this and to define the cupid's bow.

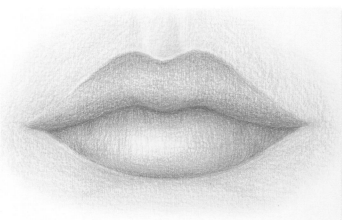

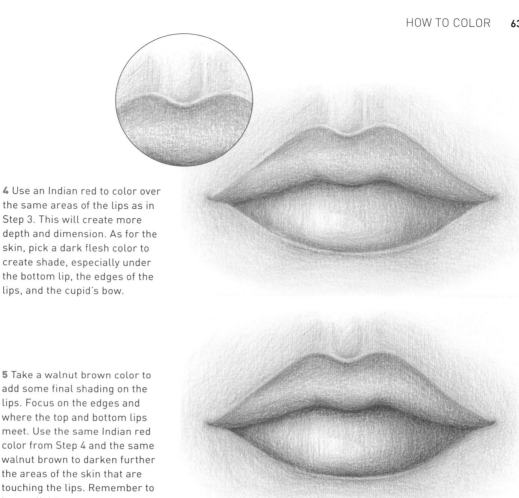

Indian red

4 Use an Indian red to color over the same areas of the lips as in Step 3. This will create more depth and dimension. As for the skin, pick a dark flesh color to create shade, especially under the bottom lip, the edges of the lips, and the cupid's bow.

Walnut brown

5 Take a walnut brown color to add some final shading on the lips. Focus on the edges and where the top and bottom lips meet. Use the same Indian red color from Step 4 and the same walnut brown to darken further the areas of the skin that are touching the lips. Remember to keep a light pressure on your pencil to avoid any harsh marks.

White

6 Finally, use a blending stump to blend the colors in the lips. You can also use a white pencil to smooth the color of the skin around the lips.

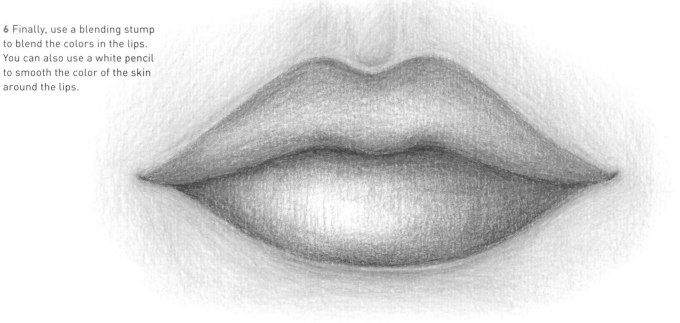

LIPS WITH TEETH

When it comes to teeth, minimal amounts of coloring is needed. In fact, we won't really be coloring in the teeth—instead, we will be creating gray shadows to highlight and differentiate each individual tooth.

Dark flesh

Cool gray

Red

Medium gray

Rusty red

Light flesh

1 Color in the lips with a base dark flesh color. Leave some spots on the upper and lower lips white, to show where the light hits. Use a cool gray to lightly color over the teeth.

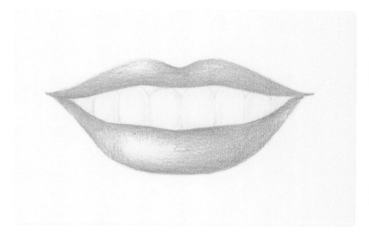

2 Choose a red to go over the same areas as in Step 1. Remember to keep some of your strokes curved in the shape of the lips, to imitate the natural lines and texture. Use a medium gray to define the shape of the teeth. Apply a little more pressure to your pencil to make the areas of the teeth that are close to the lips slightly darker.

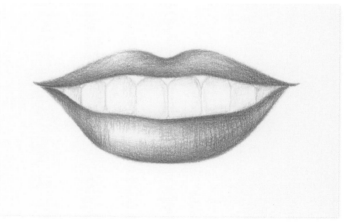

Make the teeth pop by adding a rusty red color to the gums.

3 Use a rusty red to darken the outer edges and the corner of the lips, as well as the edges close to the gums and teeth. Using the same red, lightly fill in the gums, darkening the color where each individual tooth meets the gum line. You can also start coloring in the surrounding skin with a light flesh.

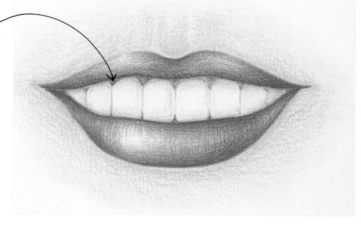

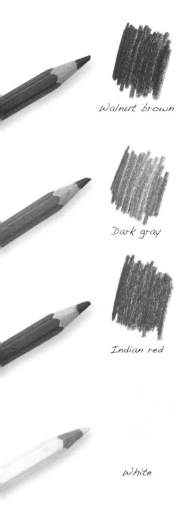

Walnut brown

Dark gray

Indian red

White

4 Take a walnut brown to add more shade and depth around the lips, as well as to darken the edges of the gums. Use this color to emphasize some of the lines and texture on the lips. Take a dark gray to lightly shade over the top and bottom of the teeth. Finally, use a dark flesh color to darken the skin around the lips and highlight the cupid's bow.

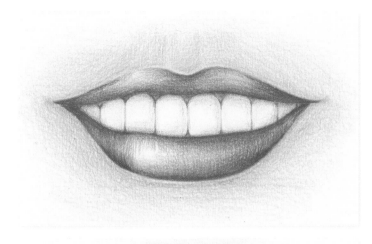

Adding details, such as the cupid's bow, makes your lips way more realistic!

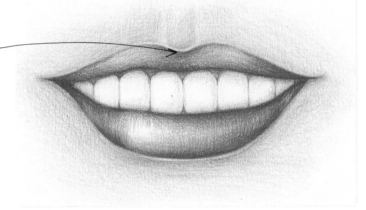

5 The lips are now done! Moving on, take an Indian red to darken further the skin around the lips. Use a walnut brown to emphasize the shadows, especially on the outer corners and edges of the lips.

6 Lastly, use a blending stump to blend the colors on the lips together smoothly. Use a white pencil to do the same for the skin and teeth.

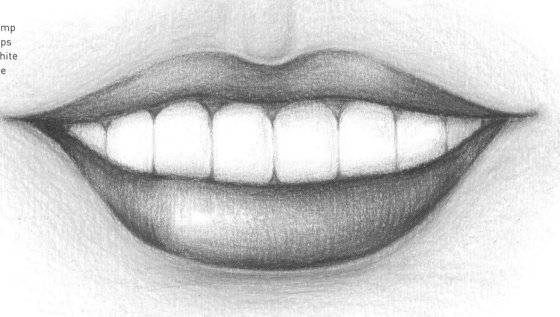

LIP SHAPES AND COLORS

Changing the shape and color of the lips will create different expressions and looks, just as it did with the eyes. You can have the mouth open or closed, smiling or with pursed lips, the teeth or tongue visible or not—you name it!

THREE-QUARTER VIEW

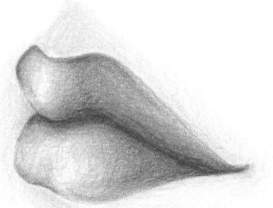

When coloring in a three-quarter view of the mouth, keep the front lighter and the edges darker to emphasize the shape of the lips.

POUT

The key to coloring lips in a pout is to exaggerate the curved strokes on the lips, giving the illusion of fuller and rounder lips.

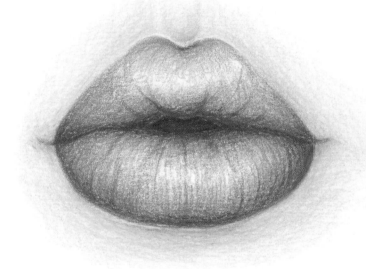

OPEN MOUTH

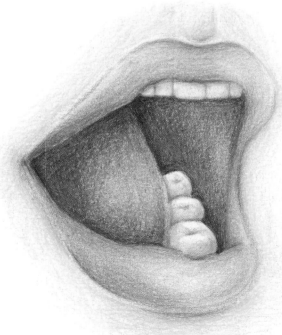

The main thing to remember when coloring an open mouth is to always darken and add shadows to areas that come into contact with another element. This is a general rule for coloring in objects. For example, you must darken the area between the tongue and the lips to clearly differentiate the two.

PLAY WITH COLOR

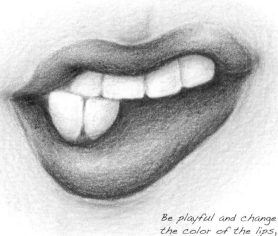

Be playful and change the color of the lips, like applying lipstick!

SERIOUS EXPRESSION

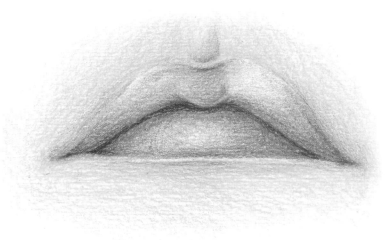

You can alter the whole expression and mood of a face by changing the shape of the lips. By simply straightening the bottom lip, the mouth appears to be frowning.

FIERCE EXPRESSION

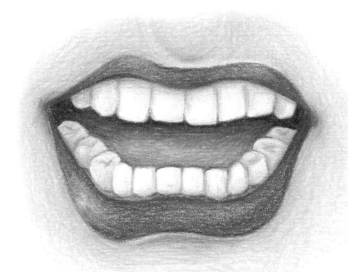

By exaggerating the curves of the lips and showing the teeth, you can create a more fierce expression. Darkening the color of the lips can also exaggerate the fierceness.

SWEET TREAT

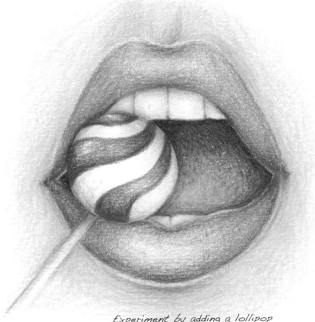

Experiment by adding a lollipop and changing the lips into a bold color scheme.

RAINBOW LIPS

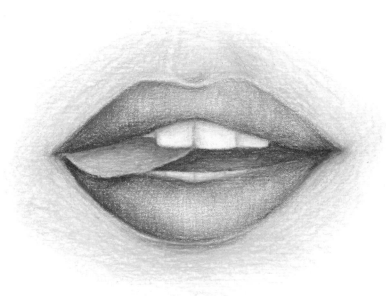

Why not add a rainbow of color to the lips? Be daring!

TRY IT YOURSELF

Colors used

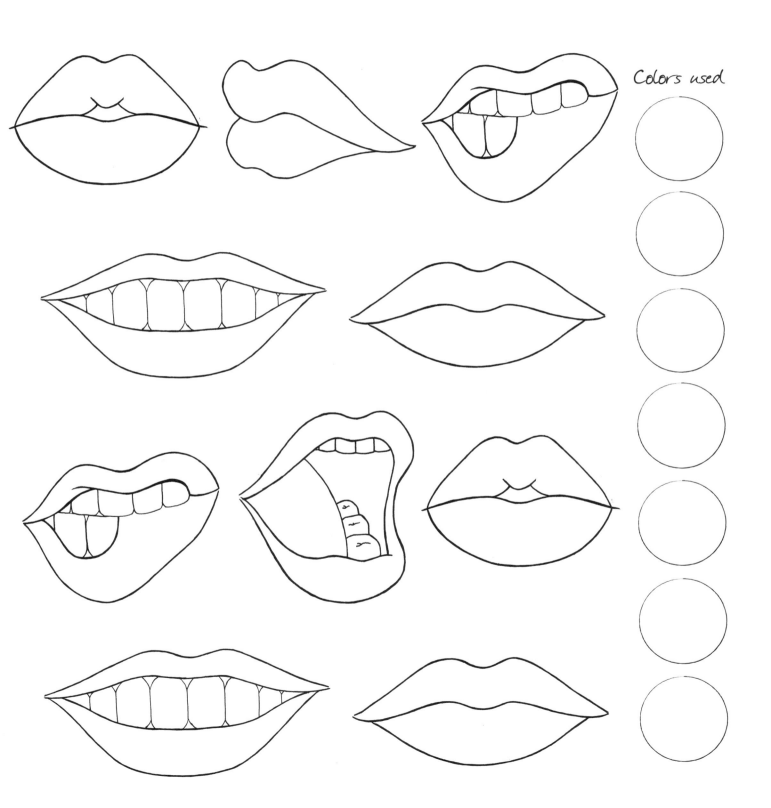

Colors used

SKIN

PINK-TONED SKIN

Having learned how to color specific facial features, it is time to put it all together and learn to color the whole face. The key to coloring the skin is to gradually define the structure and shape of the face, while creating shade and depth. To color pink-toned skin, you will need a beige or flesh color.

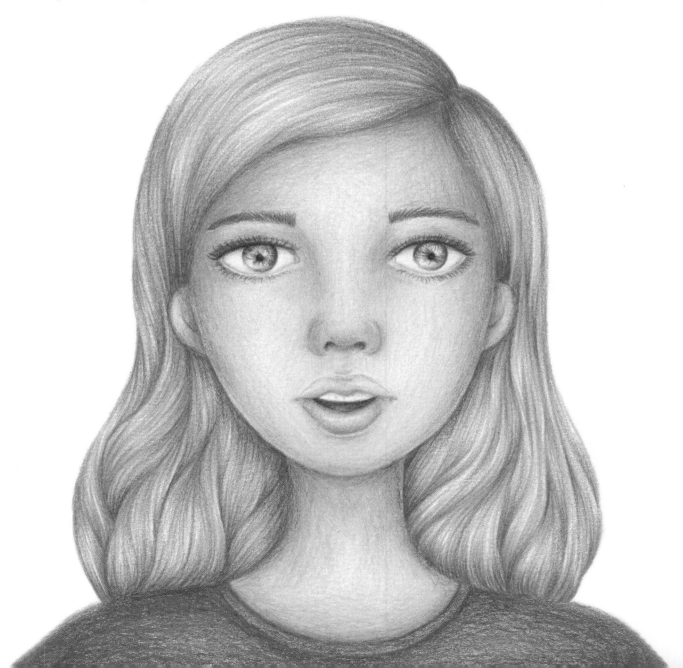

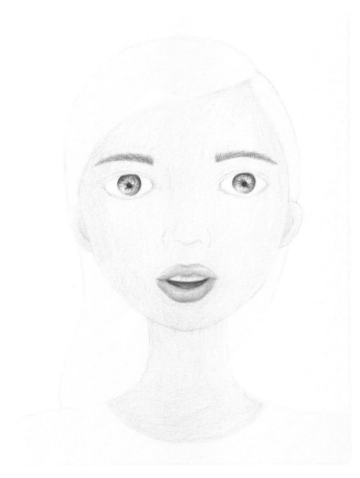

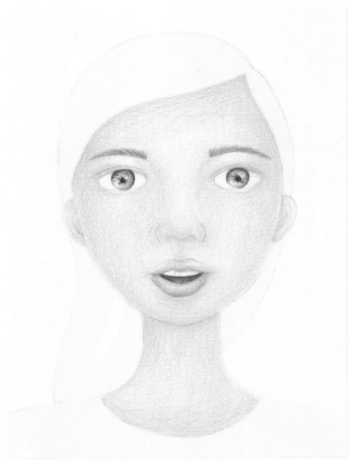

1 Begin by creating a base color: lightly color the entire face with a light flesh.

2 With the same flesh color you used in Step 1, begin to define the nose, and darken the edges of the face, eyelids, and hairline. Extend the color to the ears and neck.

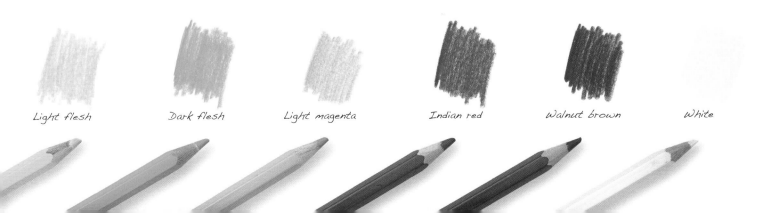

Light flesh *Dark flesh* *Light magenta* *Indian red* *Walnut brown* *White*

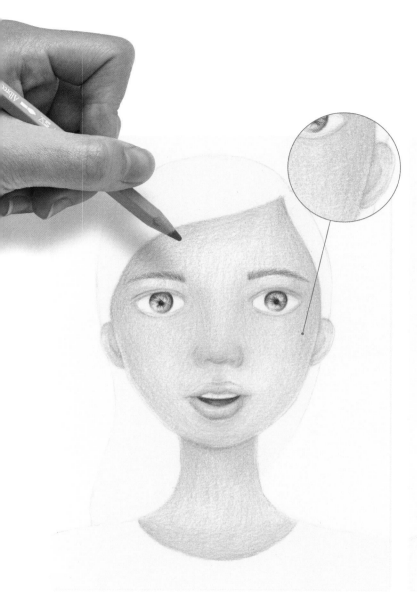

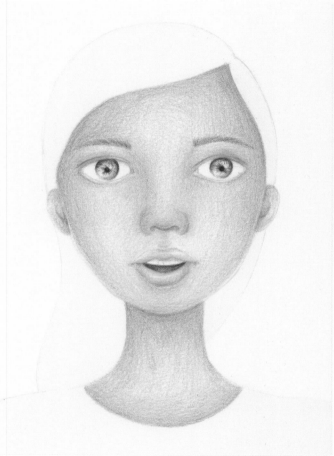

3 Take a dark flesh color to go over the same areas you darkened in Step 2. At this stage, you can also add a bit of blush to the cheeks by selecting a light magenta and gently coloring in the apple of the cheeks.

4 Use an Indian red to shade the face further, focusing on the edges of the face, chin, neckline, nose, ears, eyelids, and near the hairline. Keep a light pressure on your pencil to gently build up color.

When in doubt, add shadow wherever two surfaces are touching—for example, the areas around the cheeks, the chin, or the neck.

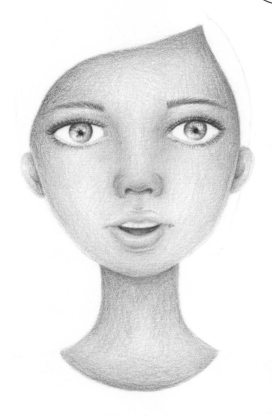

5 Take a walnut brown and lightly build more shadow and depth in the same areas as Step 4.

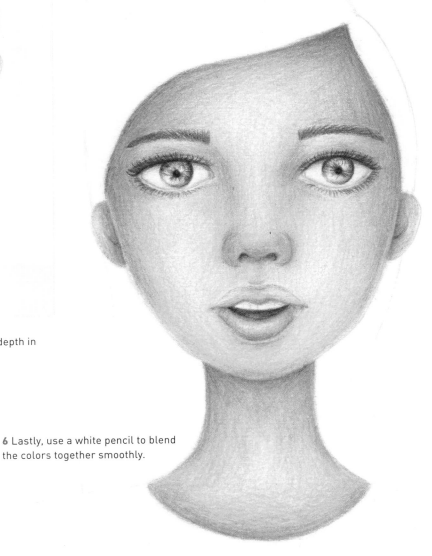

6 Lastly, use a white pencil to blend the colors together smoothly.

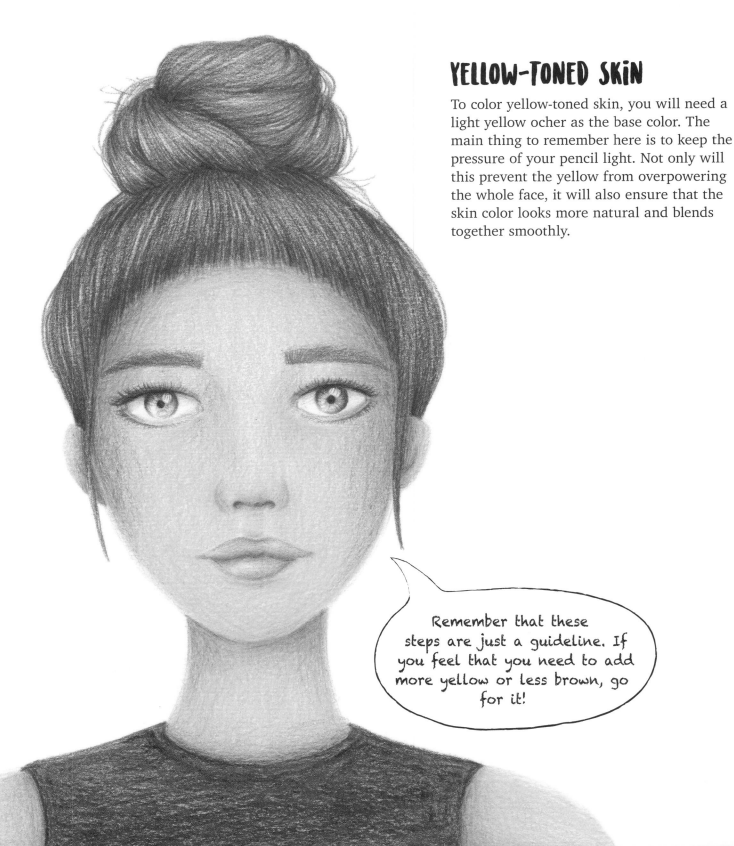

YELLOW-TONED SKIN

To color yellow-toned skin, you will need a light yellow ocher as the base color. The main thing to remember here is to keep the pressure of your pencil light. Not only will this prevent the yellow from overpowering the whole face, it will also ensure that the skin color looks more natural and blends together smoothly.

Remember that these steps are just a guideline. If you feel that you need to add more yellow or less brown, go for it!

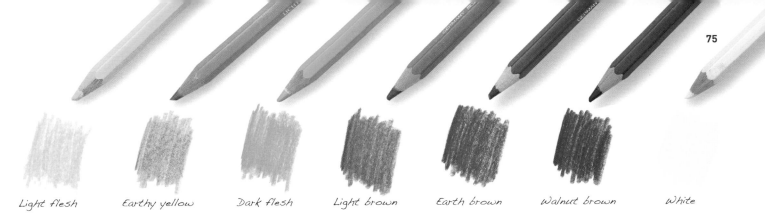

Light flesh Earthy yellow Dark flesh Light brown Earth brown Walnut brown White

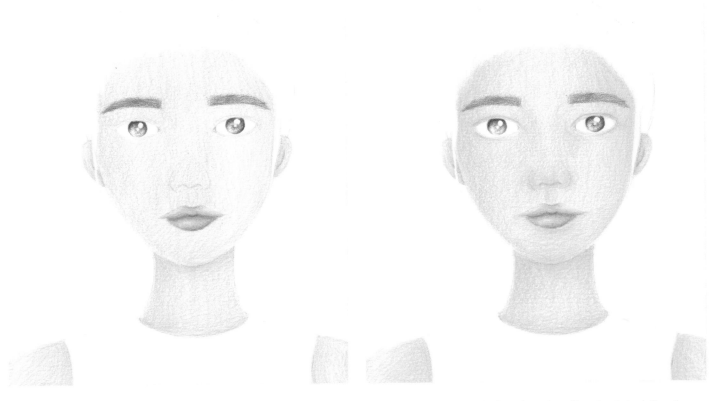

1 Create a base color by lightly mixing a light flesh with an earthy yellow.

2 Using the same light flesh and earthy yellow, begin to define the structure of the face. Increase the pressure on your pencil slightly to create darker colors, especially around the nose, eyes, lips, neck, ears, and edges of the face.

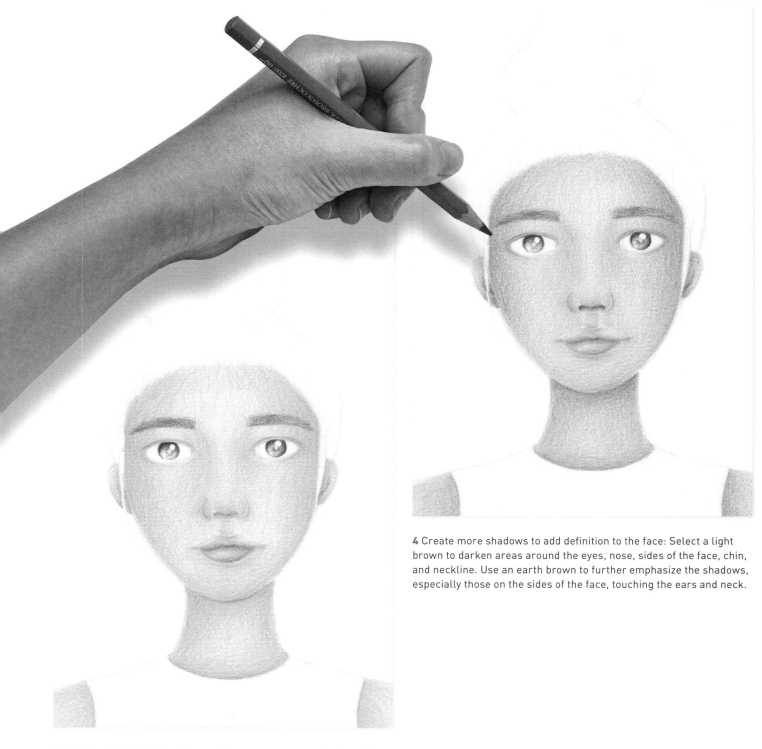

4 Create more shadows to add definition to the face: Select a light brown to darken areas around the eyes, nose, sides of the face, chin, and neckline. Use an earth brown to further emphasize the shadows, especially those on the sides of the face, touching the ears and neck.

3 Select a dark flesh to color over the same areas you darkened in Step 2. This will help give depth and dimension to the face.

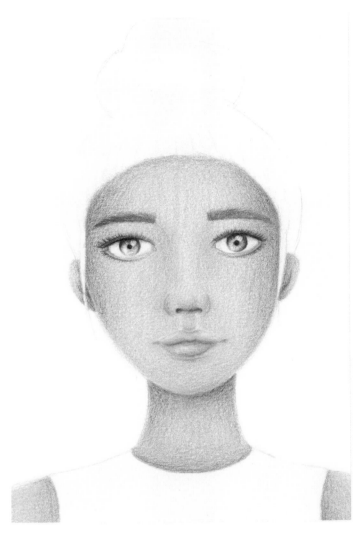

5 If you find that some of the yellow tone you created in Step 1 is being covered by other colors, take the earthy yellow to lightly color over the whole face again. Then, select a walnut brown to add the final touches of shadow around the face.

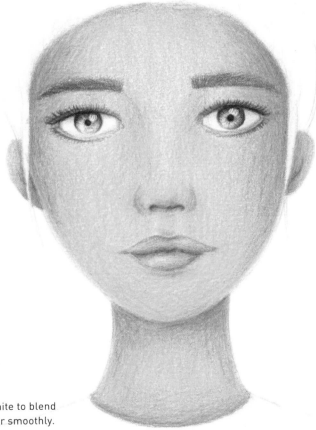

6 Finally, use a white to blend the colors together smoothly.

BROWN-TONED SKIN

To color brown-toned skin, you will need different shades of brown pencils. Depending on how dark you want the skin to be, you can alter the level of pressure that you apply to your pencil. Once again, the key to coloring the skin is to slowly build up color and shadows, layer by layer.

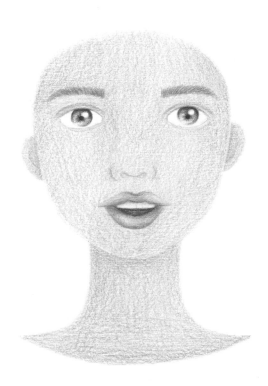

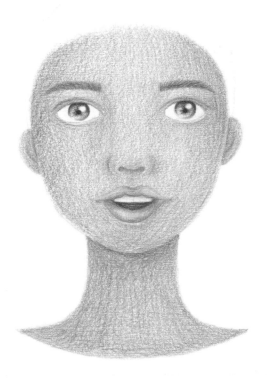

1 Mix some colors for the base color: Take a light flesh, light brown, and earth brown, and lightly color in the whole face, using the pencils in that order.

2 Take a dark flesh to lightly color over the whole face. Then, use the earth brown to color over the whole face, mixing with the dark flesh. Use the earth brown to define the structure of the face, especially the eyelids, nose, ears, neck, and edges of the face.

Light flesh *Light brown* *Earth brown* *Dark flesh* *Indian red*

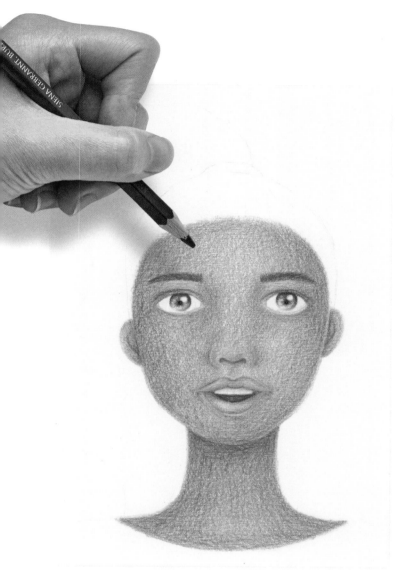

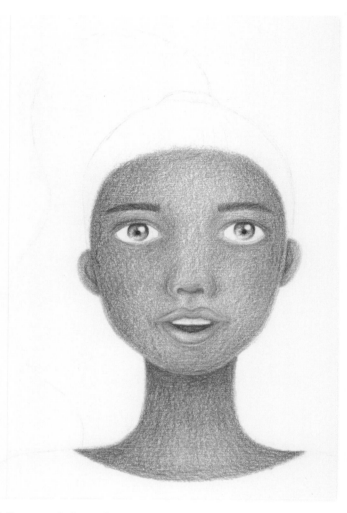

3 Now we are going to take the same earth brown from Step 2 and mix it with a light brown. Color over the whole face to darken the skin, define the facial features further, and build shadow.

4 Choose an Indian red to darken the sides of the face, as well as the nose, eyelids, ears, chin, and neck. You may also use a light magenta here to add blush to the cheeks.

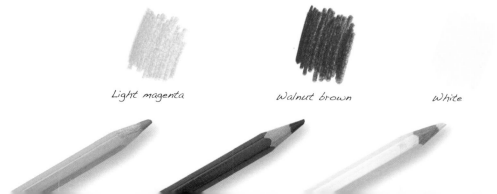

Light magenta *Walnut brown* *White*

It is important to emphasize facial features. If you feel that the color has washed out some of these details, simply go back and use the same colored pencil to redefine them.

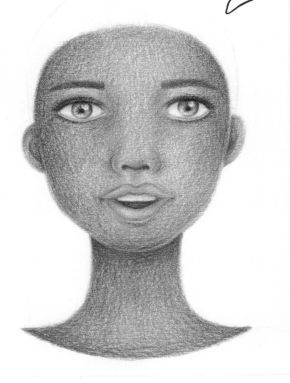

5 Select a walnut brown to go over the same areas you darkened in Step 4. This will create depth, making the face appear more realistic and three dimensional.

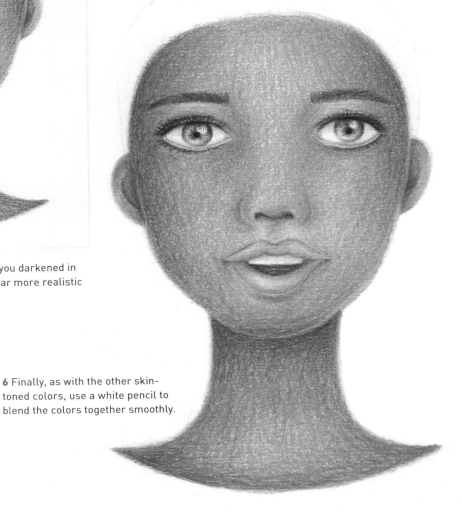

6 Finally, as with the other skin-toned colors, use a white pencil to blend the colors together smoothly.

TRY IT YOURSELF

Colors used

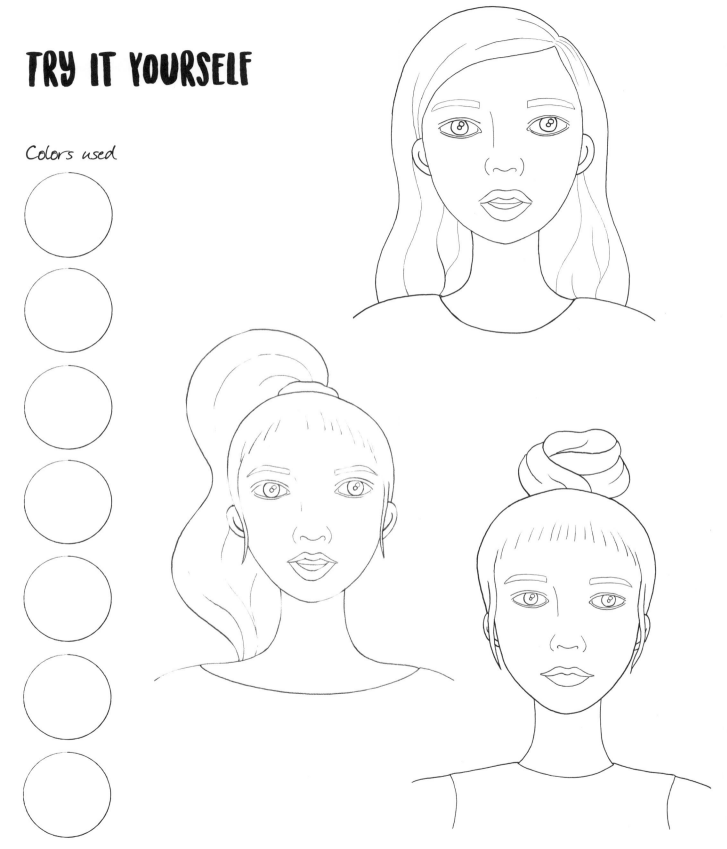

Colors used

Colors used

Colors used

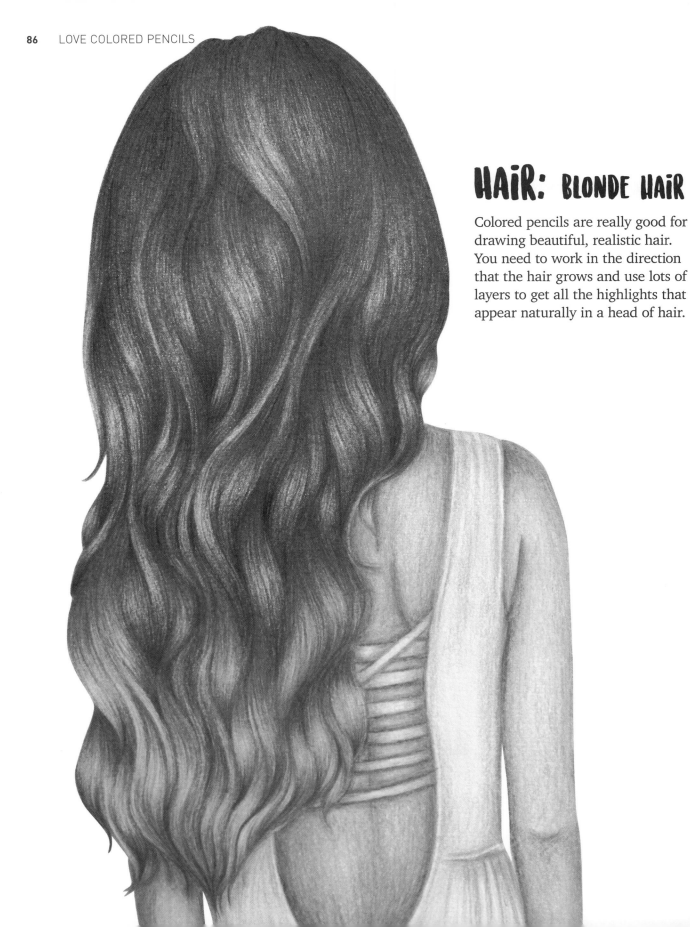

HAIR: BLONDE HAIR

Colored pencils are really good for drawing beautiful, realistic hair. You need to work in the direction that the hair grows and use lots of layers to get all the highlights that appear naturally in a head of hair.

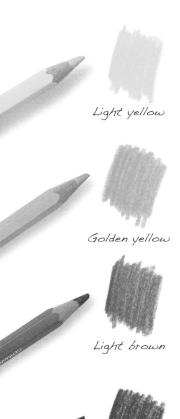

Light yellow

Golden yellow

Light brown

Earth brown

Walnut brown

1 Using the Try it Yourself templates provided on pages 90–91, lightly color in the entire hair with a light yellow pencil. Try to apply an even amount of pressure to your pencil so that the color comes out smooth and even.

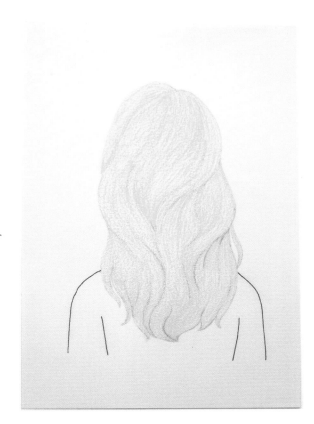

2 Use fast wrist-flicking motions to create thin hair-like strokes with a golden yellow pencil. Draw these where you want the strands of hair to part. This creates a realistic illusion of hair and creates volume and depth. In this example, I have drawn up lines within the hair to indicate the parting areas as a guide for you to know where to place the darker colors.

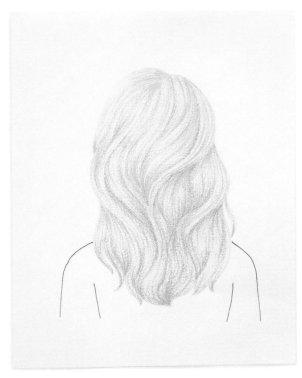

3 Build up the same areas you have used the golden yellow colored pencil on with a light brown to enhance the volume and depth. Once again, use quick and light wrist-flicking motions to create thin strands of hair in the partings. Make sure your strokes follow the wave and curl of the hair. Remember not to color in every single lock of hair—focus on the top and bottom so that you can still see the bright and golden yellow color. This creates a tonal gradation so it looks even more realistic.

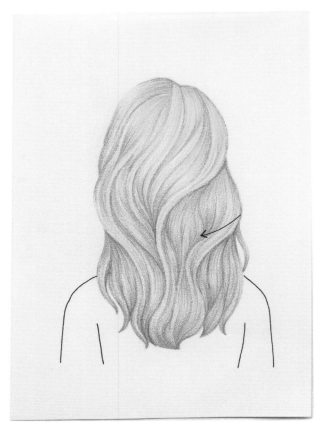

4 Use an earth brown to further darken the edges and corners of the parting. Just like before, focus on the edges of each lock of hair to create a tonal gradation. Don't apply too much pressure to your pencil, otherwise the brown color will come out too strong. You want to maintain the rich golden color of the hair. The brown colors are used for shadow purposes.

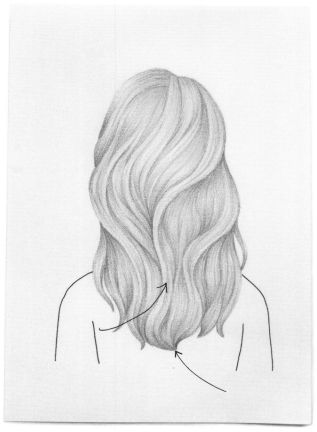

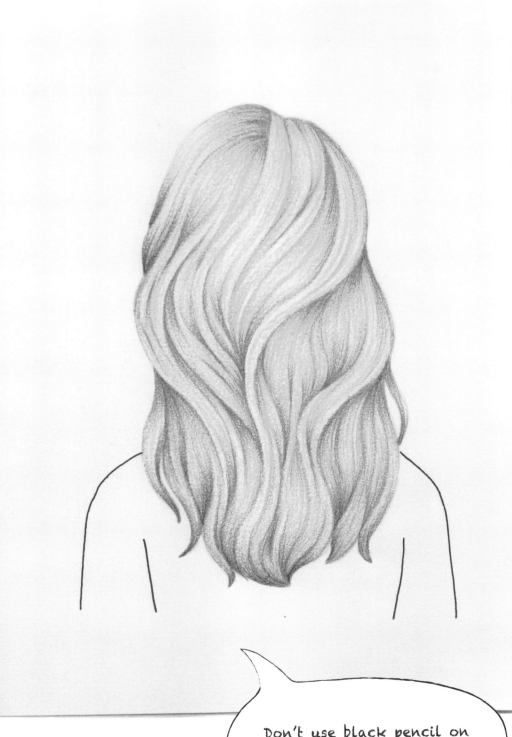

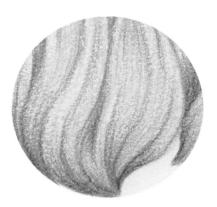

5 Pick a few hair parting areas to darken even more. Use a walnut brown and gently use quick wrist-flicking motions in those areas. Try to keep your strokes quite short, especially in edges and places where different locks of hair overlap each other.

Don't use black pencil on blonde hair—it can take on a greenish tone.

TRY IT YOURSELF

Colors used

Colors used

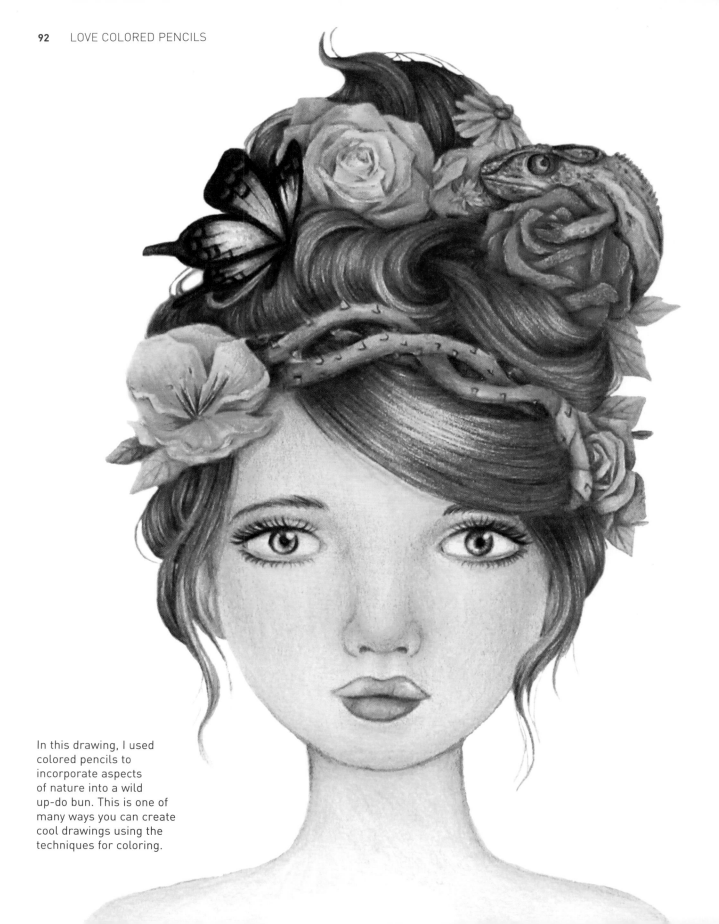

In this drawing, I used colored pencils to incorporate aspects of nature into a wild up-do bun. This is one of many ways you can create cool drawings using the techniques for coloring.

UP-DO BUN: BRUNETTE

Here I show you how to create brown-colored hair in an up-do style. You can use the same color combination and steps to create other brunette hairstyles. The key to creating realistic-looking hair is the detail, filling the whole shape with individual pencil strokes.

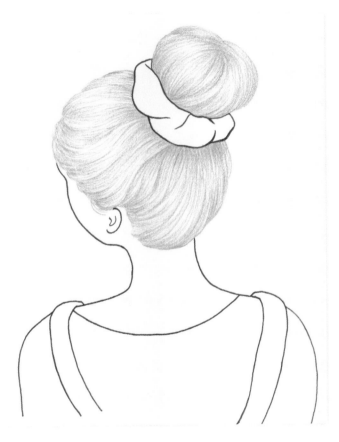

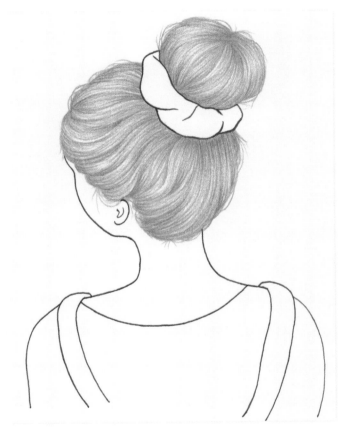

1 Start by picking a light brown as the base color of the hair. Make sure your pencil is sharp, and create thin strokes, outlining the shape of the strands of hair and where partings will be. Use small and quick wrist-flicking motions when creating the strokes, which should be curved, to follow the shape of the head.

2 Using the same color, darken the strokes to further define strands of hair and partings. Add short strands of hair coming out from the edges of the head.

Light brown

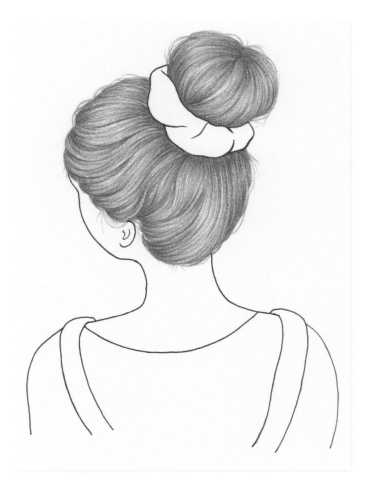

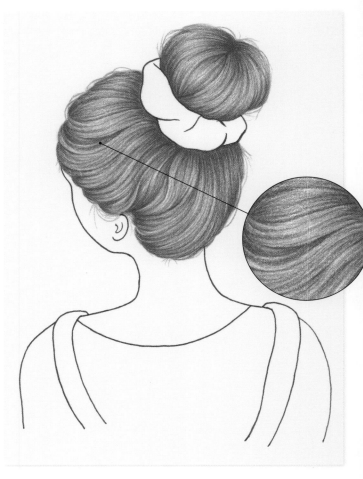

3 Choose an earth brown to create shadow and depth to the hair. Further darken the hair around the edges and the partings you have created. Remember to keep your strokes thin and to follow the shape and curve of the head.

4 Use a walnut brown to darken the same areas as in Step 3. You should also focus on darkening the areas of hair near the scrunchy and the skin.

Earth brown *Walnut brown* *Black*

5 Use black to add the
last layer of shadow
on the hair. Focus the
color on the edges and
corners of where
different strands of
hair and partings meet.
Keep a light pressure
on the pencil to prevent
the black from
overpowering
the brown.

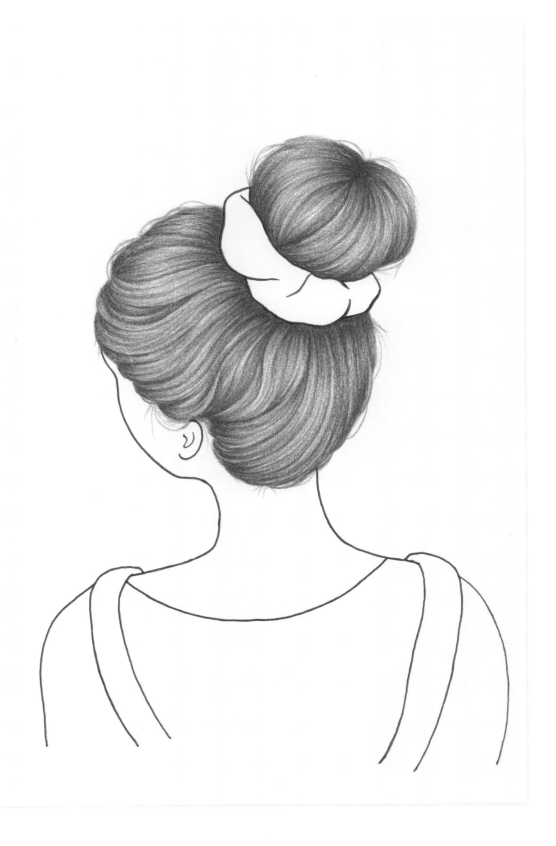

TRY IT YOURSELF

Colors used

Colors used

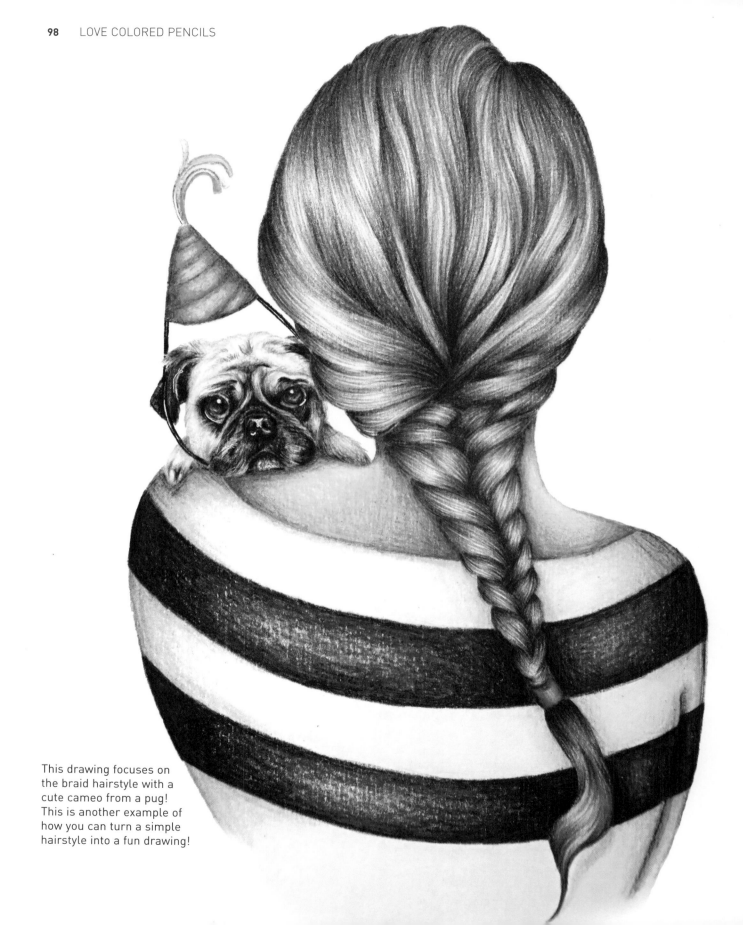

This drawing focuses on the braid hairstyle with a cute cameo from a pug! This is another example of how you can turn a simple hairstyle into a fun drawing!

BRAID: OMBRE HAIR

Braids are always a fun hairstyle to color in, and there are so many different braid styles to choose from. The style shown here is ombré hair in a French braid. Ombré hair has different tones of color that blend into each other gradually, from dark to light.

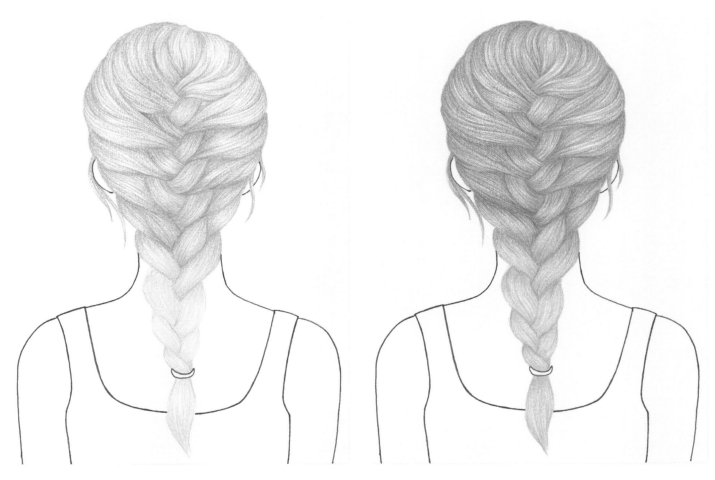

1 Create a base color with a light brown and a sunshine yellow, lightly filling in the hair with thin strokes. Make sure that the strokes follow the curvature of the head and that they flow in the same direction as the hair.

2 Using the same brown and an earthy yellow, begin to darken the hair to create depth. Increase the pressure on your pencil to do this. Define partings in the hair and areas where strands of hair overlap each other.

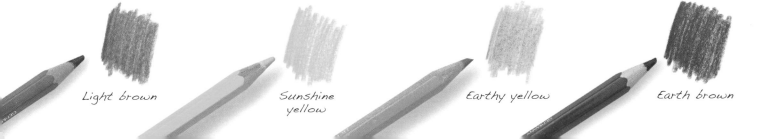

Light brown *Sunshine yellow* *Earthy yellow* *Earth brown*

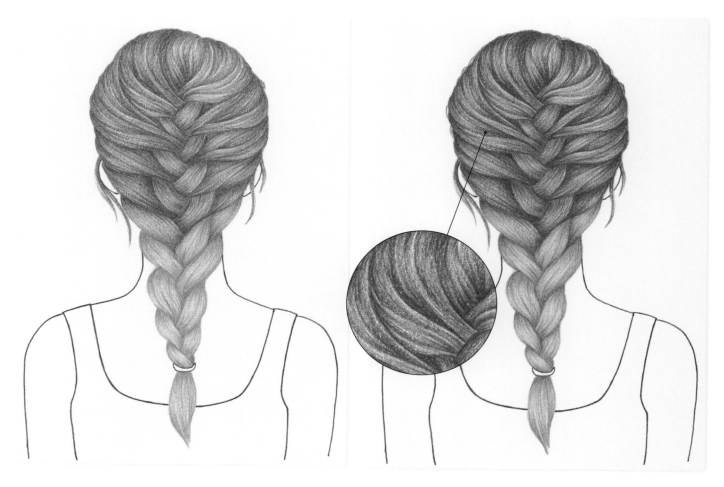

3 Select an earth brown to darken the strands of brown hair on the top half of the head. Focus more of the color on the edges and corners of the strands of hair that touch or overlap each other. Then, select a walnut brown and do the same for the blonde half of the hair. Add some of the sunshine yellow color you used previously to the brunette half of the hair, creating a smooth transition between the two colors.

4. Still using the walnut brown, add even more shadow and depth to the brunette half of the hair. Increase the pressure on your pencil to create a dark, rich color. Repeat this step on the blonde half of the hair, this time using a light brown.

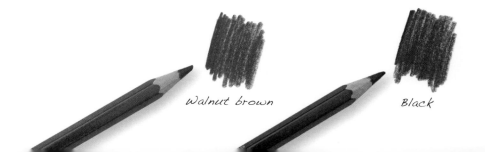

Walnut brown

Black

Don't worry too much about symmetry. Hair will appear more realistic if it is messy, the parting is uneven, and there are flyaway strands.

5 Use the walnut brown and black pencils to add the final touches of shadows. Keep light pressure on your pencil so that the color doesn't come out too strong and unnatural-looking. Focus the color on the edges of head and where strands of hair meet.

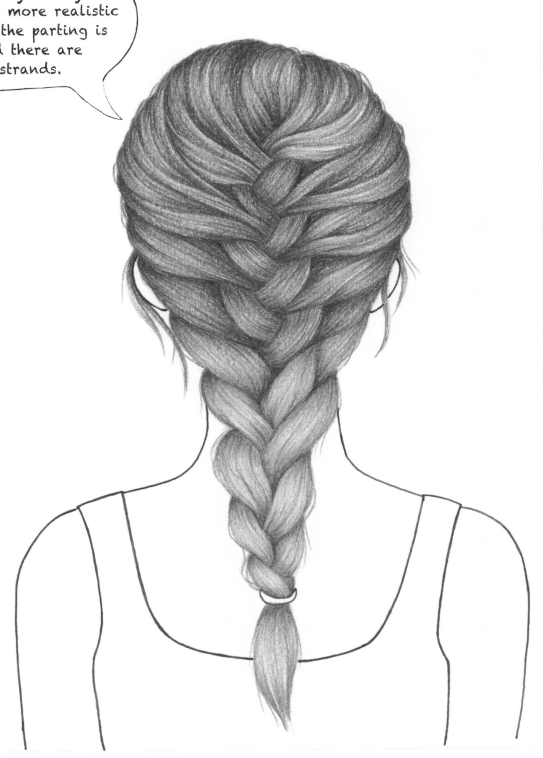

TRY IT YOURSELF

Colors used

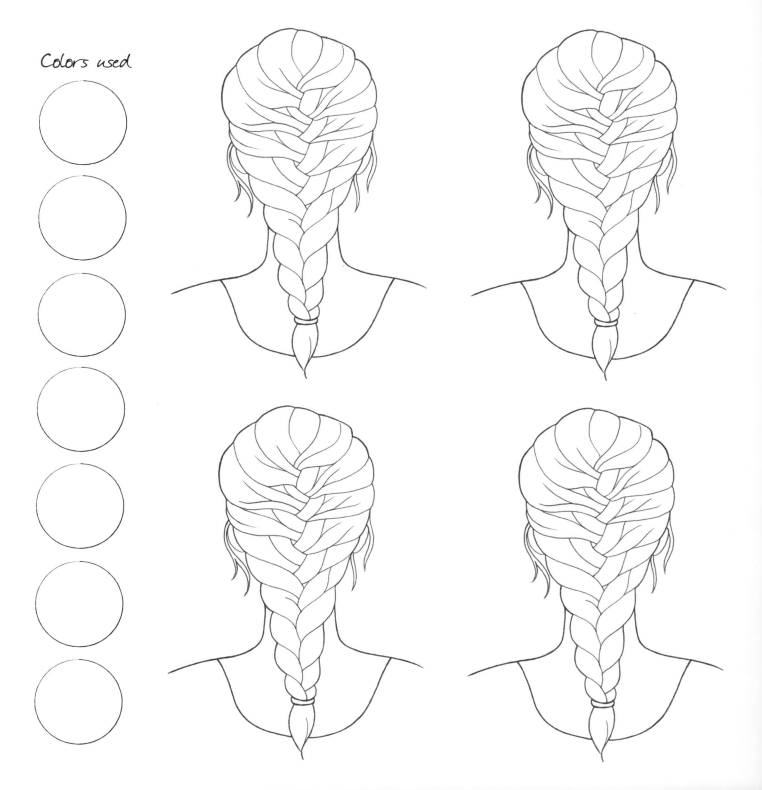

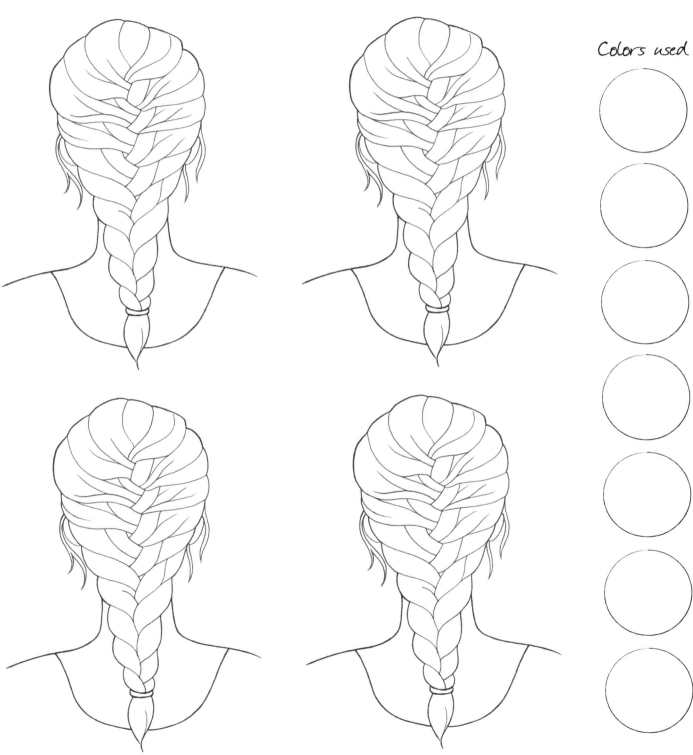

Colors used

SHAPE AND COLOR

When it comes to hair, there are endless possibilites. Create different styles—such as updos, braids, ponytails, and bunches—and go wild with color. Why not experiment with dip-dyed ends or all-over-rainbow hair?.

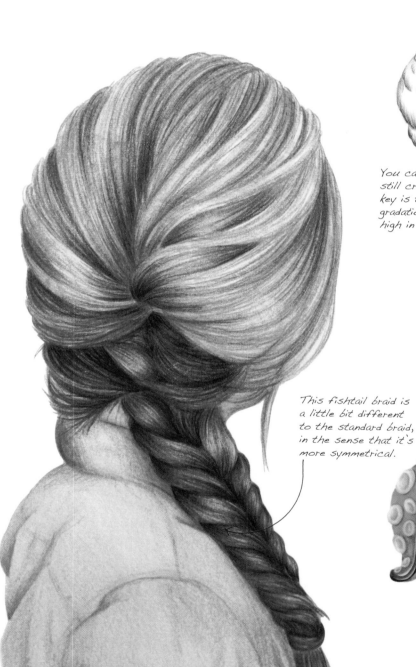

You can have a limited color palette and still create something wonderful. The key is to establish various tonal gradations and ensure the colors are high in contrast to highlight the hair.

This fishtail braid is a little bit different to the standard braid, in the sense that it's more symmetrical.

This is an example of blending elements of an octopus into the hairstyle. Be creative and use unconventional hair colors!

You can vary the angle and side of the head on which the braid is placed. This particular braid is leaning to the left, revealing a tattoo on the girl's back.

Why not apply the colors of the rainbow to your character's hair to give her that quirky, bang-on-trend look?

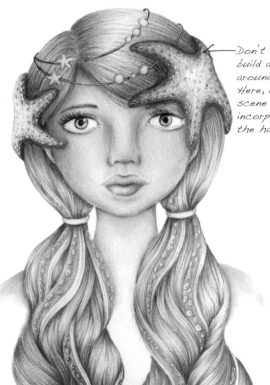

Don't be afraid to build a theme around the hair. Here, an aquatic scene is incorporated into the hairstyle.

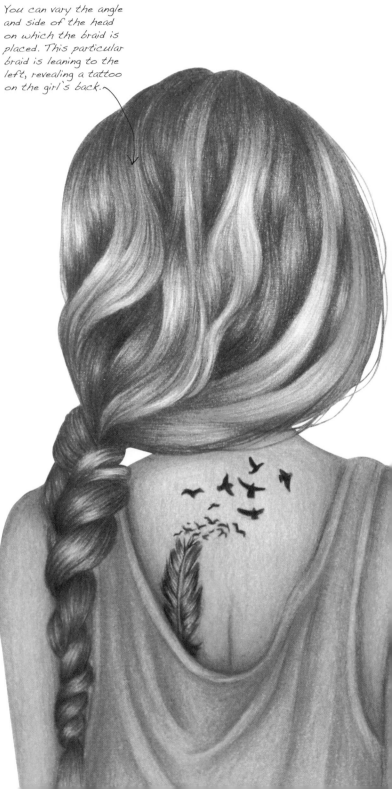

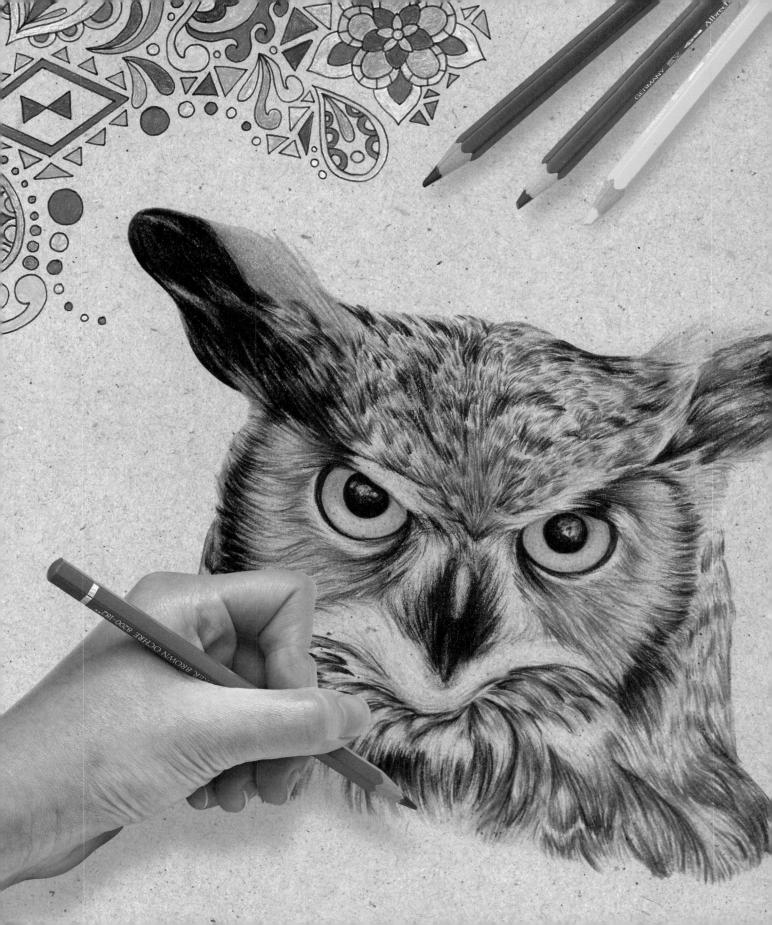

chapter

3

MY FAVORITE THINGS

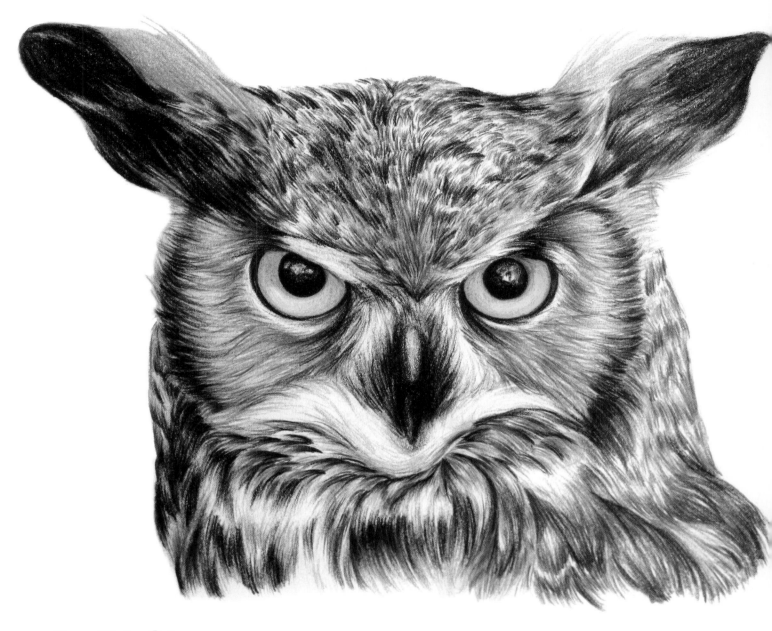

FEATHERS: OWL

When it comes to coloring in animals and their feathers or fur, the key is to be meticulous and patient. You must always use quick wrist-flicking motions to create the thin, smooth strokes that imitate the feathers or fur. Owls are a good subject to color when it comes to practicing feather work, as they have lots of them! In this tutorial, I will show you how to layer colors and tone to create depth and dimension.

1 To color in the owl's eyes, take a sunshine yellow and fill in the iris. Then use a darker, golden yellow to shade in the edges of the iris, especially near the top. With a light brown, go over the same shadow areas. Fill in the pupil and outline the bottom edge of the eyes with black. Add a few strokes of feathers on the inner corners, too.

2 Start to build up the feathers around the center of the face, mainly near the beak and eyes. Pick a light and a dark gray and use quick wrist-flicking motions to create light and thin strokes of feathers in the areas shown in the drawing. Then take a black and, with light pressure on the pencil, start layering darker strokes over the same areas you filled in with the grays. This will create shadow and depth. Then, using the black, color in the beak, leaving a spot of white in the center. Use light brown near the bottom of the beak.

Sunshine yellow Golden yellow Light brown Black Light gray

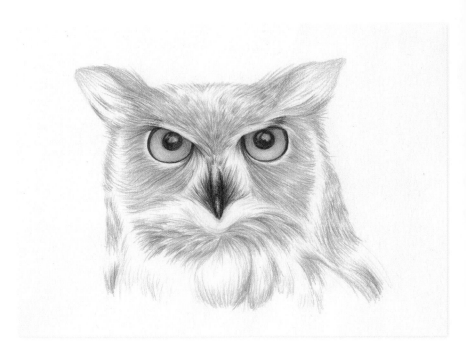

3 Create the base color for the feathers on the rest of the owl's body. Start with an earthy yellow and lightly mark out where the brown feathers will be. Color in those areas lightly. Then, take a light brown and, using quick wrist-flicking motions, fill the body with darker strokes, which imitate the feathers. Leave the areas shown in the drawing as white untouched, as they will be filled in with a different color.

By increasing the pressure on your pencil, you can create a darker layer of feathers.

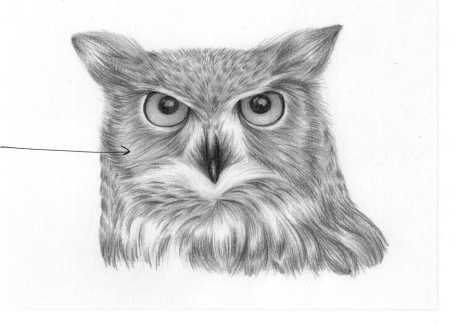

4 Take an earth brown and fill the white areas with this color. Keep the strokes light and thin to give the impression of soft, smooth feathers. Use this earth brown to go over the base color in Step 3, creating shadows and depth.

Dark gray

Earthy yellow

Earth brown

Walnut brown

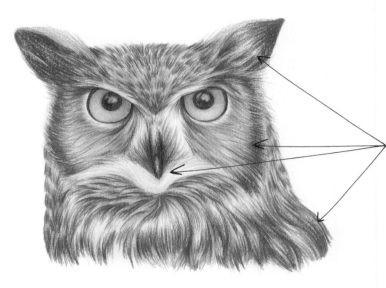

Darken the areas of feathers you created in Steps 3 and 4.

5 Use a walnut brown to create even more layers of feathers and shadow. Darken the areas of feathers you created in Steps 3 and 4, especially near the edges of the face and body, and the areas around the eyes, beak, and ears.

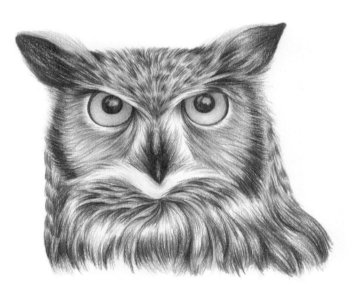

6 Use black to add in the final touches of shadow and the last layer of feathers. Focus the color near the eyes, beak, ears, and edges of the body.

TRY IT YOURSELF

Colors used

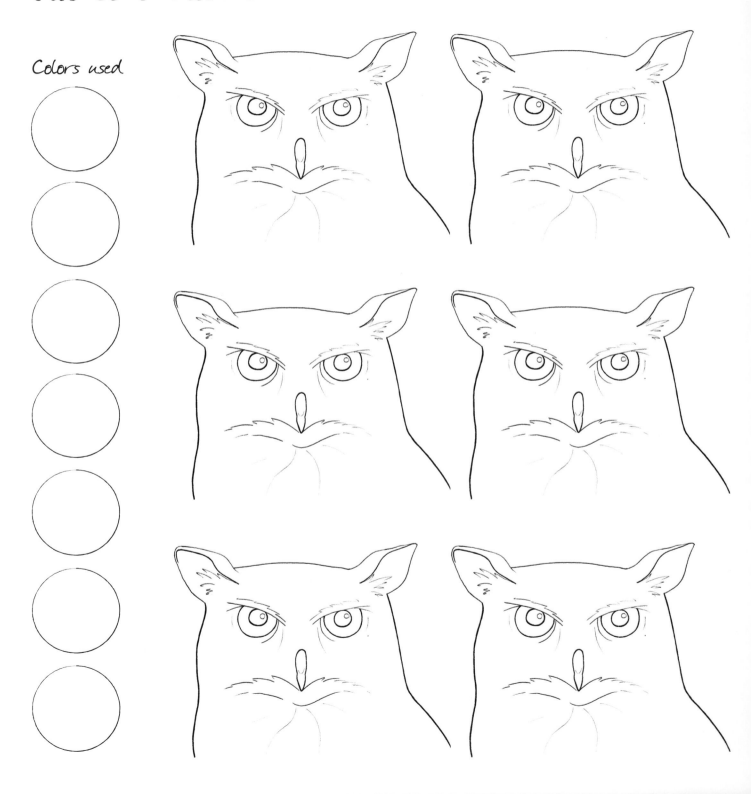

Colors used

FUR: LEOPARD

Coloring in a leopard can be even more tedious and time consuming than an owl—but the results are stunning. The key technique here is to build up layers of different colors and tones to create depth, shadow, and a base for the distinctive black leopard prints. Multiple layers of different colors will make the fur look voluminous and full, creating an illusion of realistic softness.

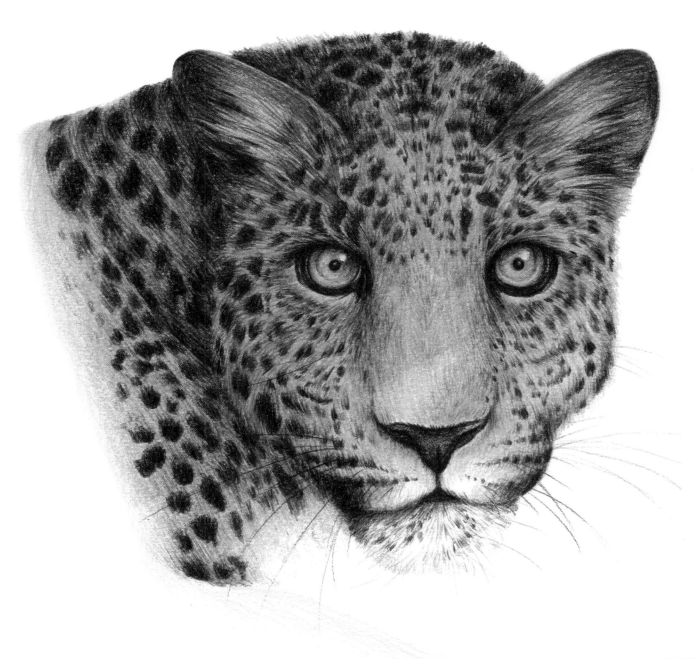

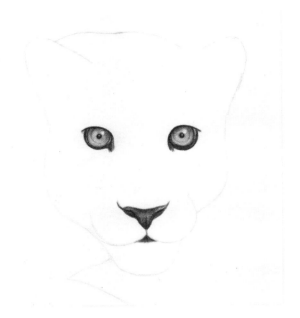

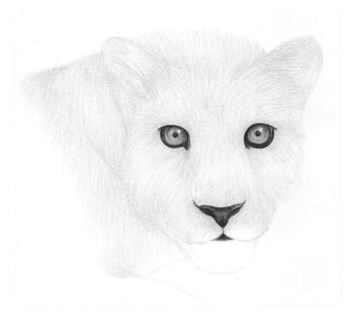

1 First, color in the leopard's eyes and nose. Using an earth green (if you don't have this color, mix a light green with a gray), lightly color in the center of the iris. Then, use an earthy yellow to lightly fill in the rest of the iris and the edges around the pupil. Take a walnut brown to darken the iris near the edge of the eye, creating shadow. Outline the eye with black, and color in the nose and mouth.

2 Select a light yellow as the base color of the leopard. Lightly color in the face and body using small, soft strokes.

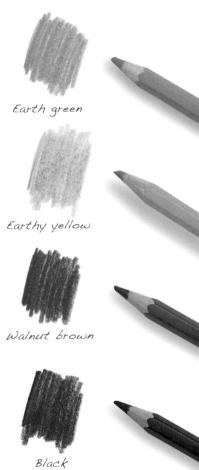

Earth green

Earthy yellow

Walnut brown

Black

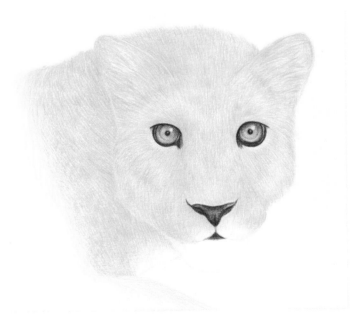

3 Take a golden yellow and repeat Step 2, building up the layers of fur to create depth.

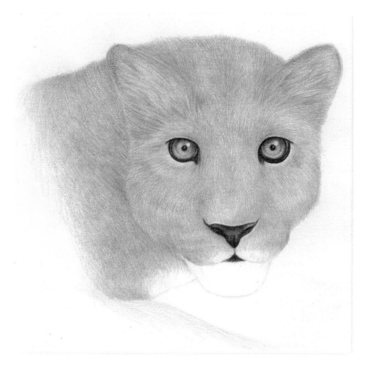

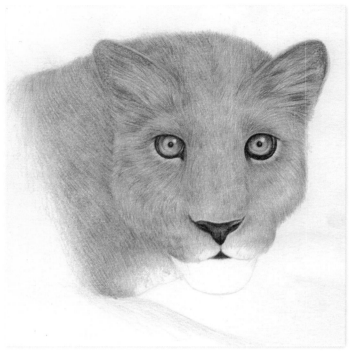

4 With a light brown, create darker strokes over the face and body. Keep a light pressure on the pencil so that you don't cover the colors you have used previously. This will make the fur appear more natural and smooth.

5 After that, take an earth brown to add more fur and shadow in areas around the neck, ears, eyes, and nose.

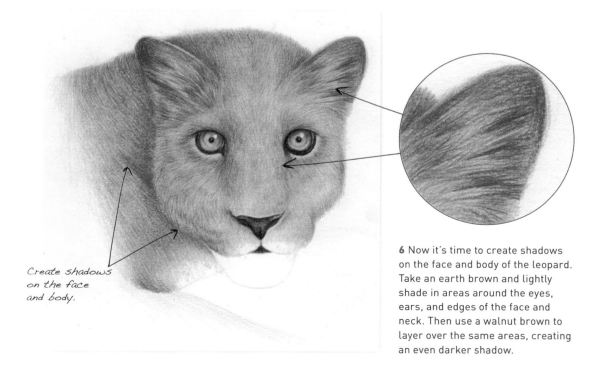

Create shadows on the face and body.

6 Now it's time to create shadows on the face and body of the leopard. Take an earth brown and lightly shade in areas around the eyes, ears, and edges of the face and neck. Then use a walnut brown to layer over the same areas, creating an even darker shadow.

Light yellow

Golden yellow

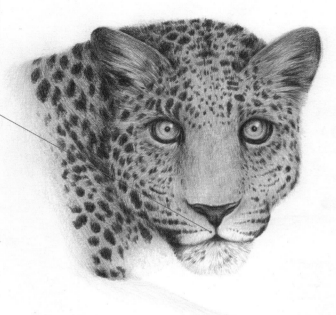

7 Now it's the fun part—adding the leopard spots! Using a black pencil, create different-sized spots all over the face and body. Vary the shape of the spots to create a natural and realistic look. Make sure the spots near the mouth and eyes are smaller. Use the black to create strokes of fur below the mouth.

Light brown

Earth brown

8 You will notice after coloring in the spots that some of the base color may appear fainter. Select the different yellow and brown colors you used to color in the leopard, and fill in some of the gaps. Then, use the black to add in whiskers. Hold your pencil slightly straighter, maintaining a light pressure, to create thinner and fainter strokes for the whiskers.

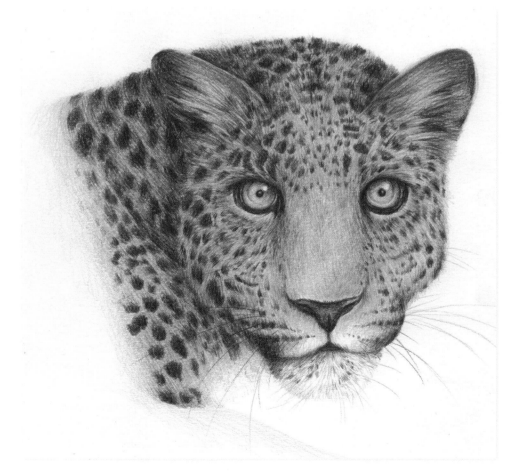

TRY IT YOURSELF

Colors used

Remember that each spot should vary in size and shape to keep the leopard looking natural and realistic!

Colors used

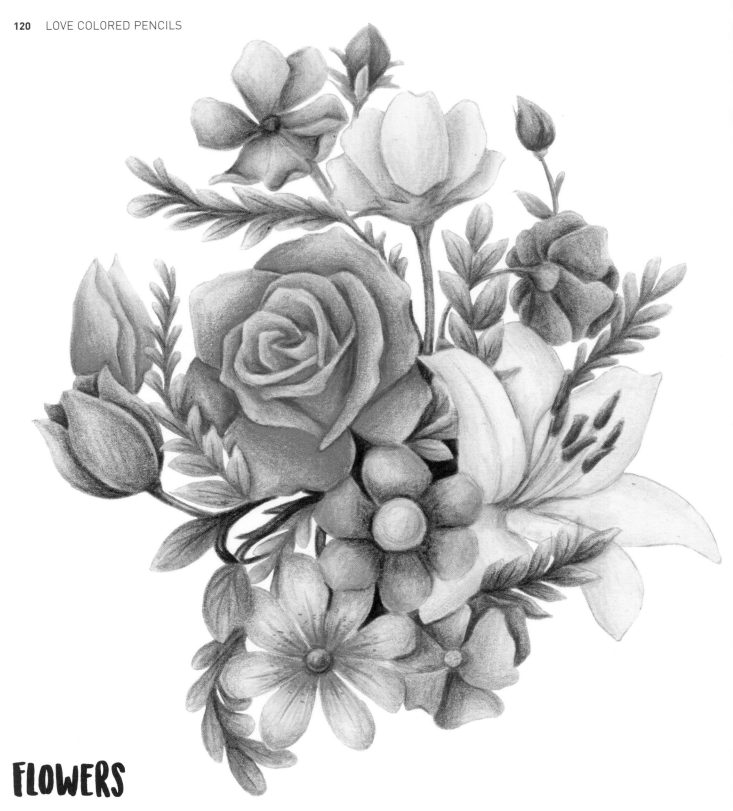

FLOWERS

Whether they're in your home or out in the wild, flowers brighten up our lives. It's only natural that you'd want to translate these beautiful blooms onto paper. Use these simple step-by-steps to do just that.

Light yellow Golden yellow Red Deep scarlet red Walnut brown

ROSE

1 Firstly take a golden or light yellow to lightly color over the top of each rose petal. This will give the flower an extra pop of color and tone down the intensity of the redness.

2 Take a red color and lightly fill in the rest of the petals. This will be the base color. Keep a very light pressure on your pencil, because red can often be quite strong and intense. Slightly darken the areas where different petals are touching or overlapping one another.

3 Using the same red, increase the pressure on your pencil and darken the petals. Emphasize the shadows on the petals by darkening the areas where petals are touching each other. This will help differentiate the different layers within the rose.

4 Take a deep scarlet red and repeat Step 3, but this time focus on where each petal is touching and overlapping another. This will help build depth and shadow. If the light or golden yellow color you used in Step 1 seems to be fading away, you can add the color back onto the tips of the petals here.

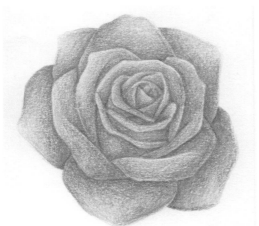

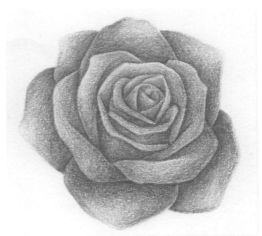

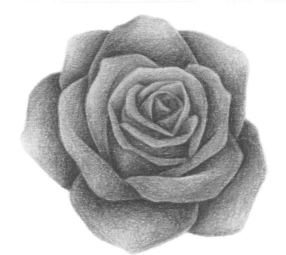

5 Lastly, select a walnut brown as the final layer of shadow. Try and keep a fairly light pressure on your pencil when using the brown, as you don't want it to overpower the red. Concentrate the colors on the edges of the petals that may be touching another petal as well as the very center of the rose. This will emphasize the flower's layers.

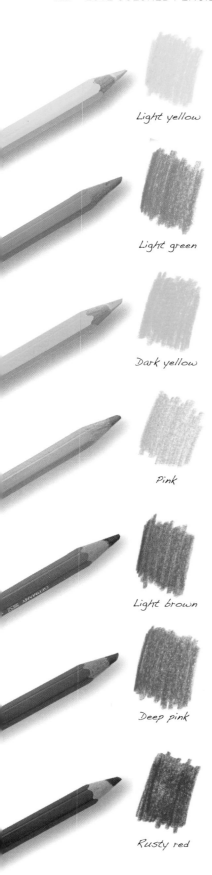

Light yellow

Light green

Dark yellow

Pink

Light brown

Deep pink

Rusty red

LILY

1 Firstly, take a light yellow and lightly color in the inner half of each petal. Add some light green to the center, then use a slightly darker yellow to color in the flower's filaments.

2 Now we will complete the base color of the flower. Select a pink and lightly color in the other half of each petal. Flick your wrists to create lined strokes to give the flower some texture.

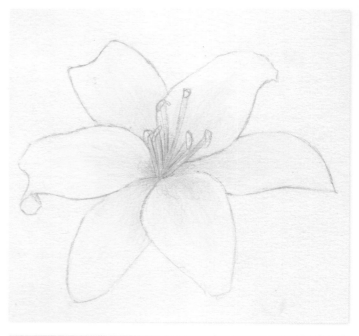

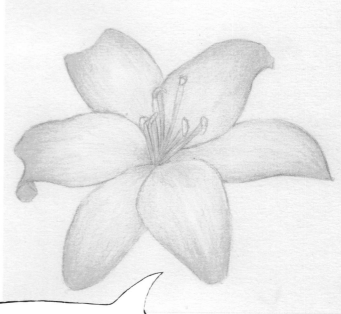

Remember, quick flicking motions of the wrist can add texture and make your flower even more realistic!

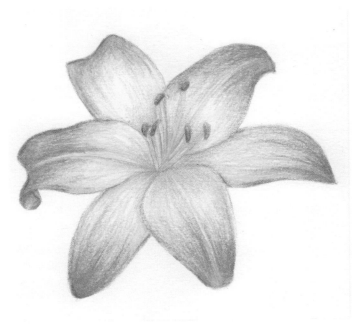

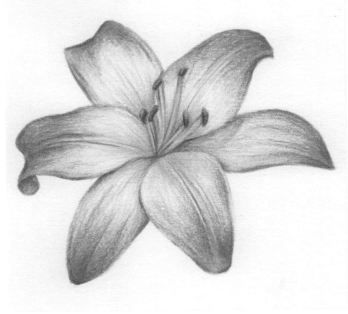

3 Take the dark yellow again to darken the yellow section of the flower. Then use a light brown to darken and differentiate each filament. Afterward, take a deep pink to darken the pink section of the flower. Try to create lined strokes leading down the center of the petals to imitate the lily's texture and patterns. Finally, use a rusty red to color in the anthers of the flower.

4 Use an earth brown to create shadow on the bottom of each petal, especially where any petals are touching or overlapping others. Once again, create some lines extending up from the middle to imitate the texture and pattern of a lily. Then, use fuschia to darken the outer edges of the petals. Finally, use an Indian red to add some shadow on the flower's anthers.

5 Finally, choose a walnut brown for the final layer of shadow. Concentrate the brown near the center of the flower where all the petals are gathered and layered on top of and next to each other. Add some shadow on the outer edges of the petals, too. Finish by adding some spots to the center of the petals and some extra dark lines running through the petals.

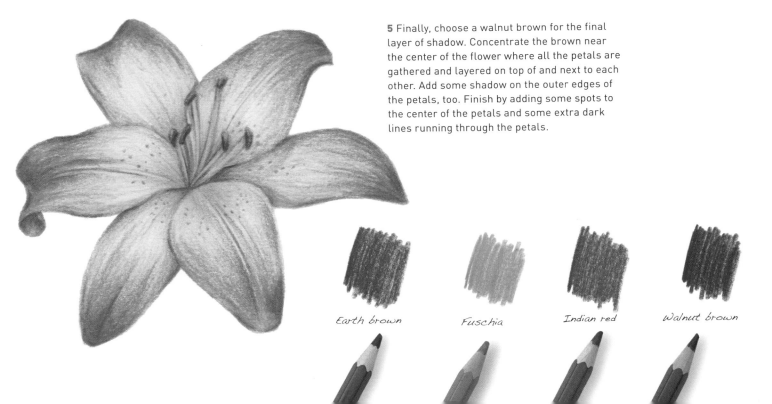

Earth brown Fuschia Indian red Walnut brown

TULIP

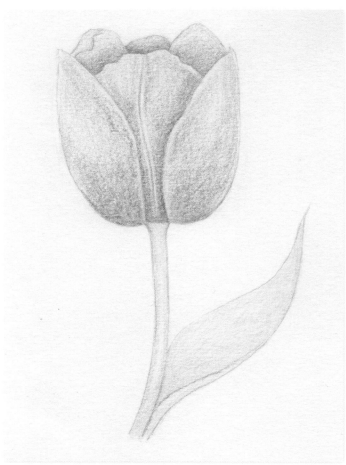

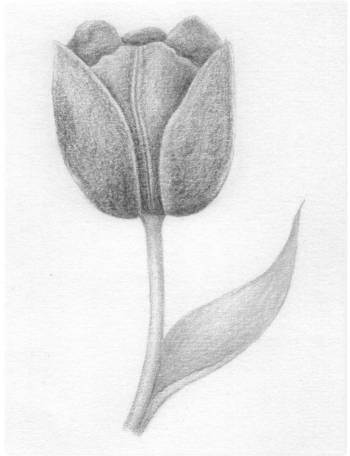

1 Create a base color for the tulip using a light magenta and a purple. Lightly color in the top half of the tulip with the light magenta and the bottom half of the tulip with purple. Use a grass green to color in the stem and leaf.

2 Use a purple violet to darken the bottom half of the flower. Do the same with a deep pink on the pink section. In order to ensure that the color mix between the pink and purple looks as natural as possible, overlap the pink and purple in different areas, extending some of the purple higher up into the pink section. Then, use a grass green to build some shadow on the stem and leaf, especially near the flower and the edges.

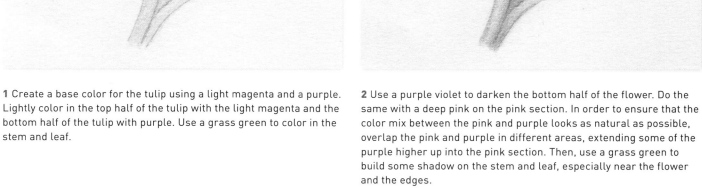

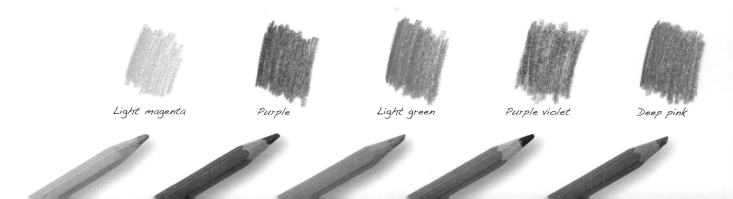

Light magenta *Purple* *Light green* *Purple violet* *Deep pink*

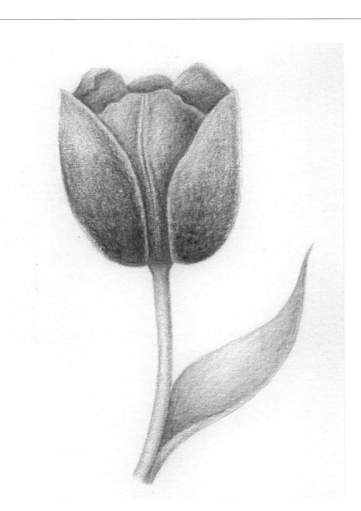

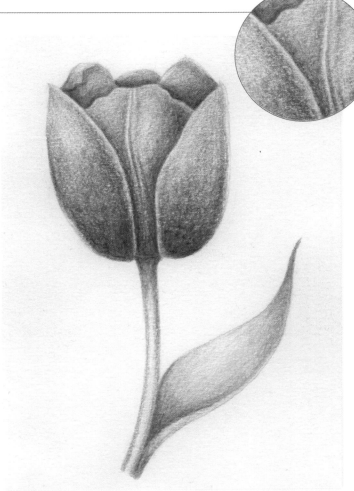

3 Use a blue violet to add shadow to the purple sections of the flower. Concentrate the color in areas where the petals are overlapping one another to emphasize the layers. Repeat the same with a fuschia. Then use a pine green to add more shadow on the stem and leaf. Make sure to darken the edges of the stem to give the illusion of a round and three-dimensional shape.

4 Lastly, select a walnut brown for the final layer of shadows. You should keep a light pressure on your pencil so that the brown doesn't overpower the original purple color. Concentrate the colors where petals are overlapping one another and where the stem, leaf, and flower meet.

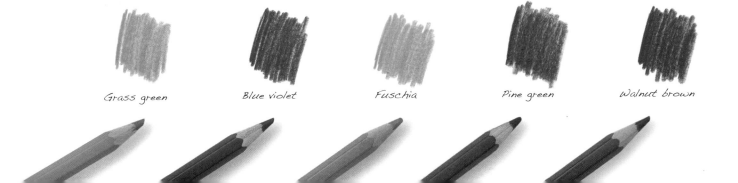

Grass green Blue violet Fuschia Pine green Walnut brown

TRY IT YOURSELF

Colors used

Colors used

CREDITS

This book would not have come to life without the help of the Quarto Publishing team. Thank you to Kate B, Kate K, Emma, Moira, Danielle, Phil, and the rest of the team who made this book possible. I would also like to thank my parents for supporting and encouraging my journey throughout this process—I hope I've made you guys proud! I would also like to give a big shout-out to my close friend Michael C for all his photography work on the hot, humid, summer days—the results look amazing. Another big shout-out to my friends—Veronica, Ivan, Michael L, Shona, Helen, and Sarah, to name but a few—who have supported my art and had faith in me from the very beginning. Last but not least, I want to give my biggest thanks to my art teacher of over 10 years, Auntie Natalie. Thank you for your patience and wisdom, and for encouraging my creativity and imagination; the foundation of my art skills could not have been built without you, and none of this would have been possible without your teaching and guidance.

Thank you Faber-Castell!

FABER-CASTELL